DRAWING BIRDS

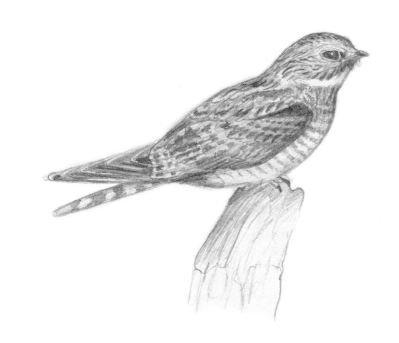

DRAWING BIRDS

A COMPLETE STEP-BY-STEP GUIDE

MARIANNE TAYLOR

SIRIUS

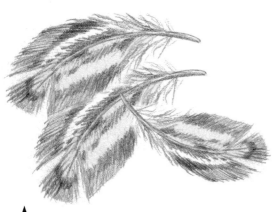

SIRIUS

This edition published in 2023 by Sirius Publishing, a division of
Arcturus Publishing Limited,
26/27 Bickels Yard, 151–153 Bermondsey Street,
London SE1 3HA

ISBN: 978-1-3988-3049-3
AD010561UK

Printed in China

Contents

Introduction: why draw birds?

The natural world is full of inspiration for artists. Many of us start out by trying a landscape or a still life of cut flowers. Drawing and painting animals is a different kind of challenge because they move, and while our artworks hold them still in a single moment, we still strive to capture some of that life and action in our lines and brush strokes.

Birds are the most eye-catching of animals. They are incredibly attractive subjects to draw and paint, thanks to their graceful forms, dynamic personalities, beautiful colours and complex patterns. A highly worked, photo-realistic painting of a bird may take many patient hours of work, but it is also possible (and perhaps even more rewarding) to capture the form and character of a bird much more quickly and simply, once you are familiar with how its body is put together and how it moves.

This book is divided into four chapters. Chapter 1 looks at the structure of birds – the anatomy of their bodies as a whole and then particular body parts, how they fit together and work together in various kinds of movement, and how their feathers are arranged on their bodies. We will explore ways of sketching the outlines of a range of differently shaped birds.

Chapters 2–4 cover more detailed, complete artworks, presented in a step-by-step format, so you can see how to build up an image from a simple outline to a finished work. Chapter 2 looks at birds in static poses – perched, standing or floating. Chapter 3 covers birds in flight, and Chapter 4 expands this theme into various types of bird movement and behaviour – diving, running, interacting and performing courtship displays – and concludes with tips on how to sketch birds from life.

Within each chapter we begin with pencil drawings and proceed through coloured pencil drawings to paintings. Various styles are used, from 'fast and loose' to intricately detailed. The subjects chosen for this book represent a wide variety of different bird families, from hummingbirds to albatrosses and ducks to parrots, and you will find species representative of every continent on Earth.

VISUAL REFERENCES

Drawing birds from life (see pages 124–7) is wonderfully challenging and will do great things for your observational skills, but it is far from easy and you will probably want to make use of non-moving reference material, especially when starting out. There are many online sources of copyright-free photographs of birds, and various 'images for artists' groups on social media platforms.

Copying a photographer's work without permission is a breach of copyright, but many photographers are happy to oblige if you ask permission (remember to let them see the finished work if you are happy with it!). You may also want to take your own bird photographs for use as reference. Birds are not the easiest photographic subjects, but many devices (cameras and phones) have sufficiently powerful lenses for decent shots, and in any case you don't necessarily need an award-winning photo.

The firecrest photo here was taken in poor light conditions, but provided a decent enough reference for the painting, which was made crisper and brighter. Sketching birds from the television or online videos is another fun option, especially as you can slow down playback, or even pause and rewind.

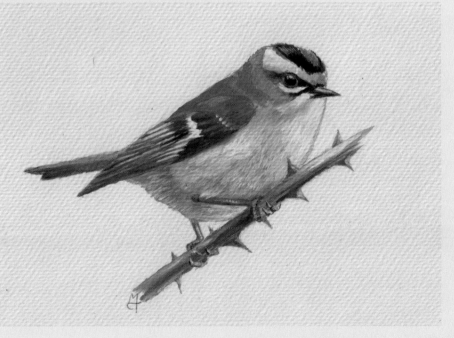

Materials and techniques

Anything that leaves a mark on paper can be used for sketching, but to begin with you're probably going to reach for a graphite pencil or perhaps a pen. All the drawings in this book start with a pencil outline, even those where colour is added with paint or pastels at a later stage.

Pencils come in a range of grades: those with softer leads are graded B for black and increase in softness from B (a mid-range pencil) to 9B (the very softest). Harder pencils are graded H to 9H (very hard). The standard pencil in the centre of the scale is HB (sometimes called F instead), with 2H making a harder, fainter line and 2B a softer, blacker one. Most art shops will sell up to 6H and up to 8B pencils, and it's helpful to have a range.

Adding colour

Coloured pencils may or may not be water-soluble and come in every conceivable colour. Pencils and pens of all kinds are best used on a good-quality cartridge paper.

You can also buy pastel pencils and stick pastels, which are soft and intensely coloured, and suitable for use on tinted and textured paper. Chalk pastels are crumbly, while oil pastels have a more crayon-like texture. Drawings made with pastels and soft pencils are liable to smudge, so use fixative spray to protect them when they are finished.

Using paint

The painting exercises in this book use gouache and watercolour. Both are water-soluble, but gouache paints are opaque, meaning that stronger colours can be achieved and mistakes can be painted over. This makes gouache probably the most easily used, forgiving and beginner-friendly of all the paint types. For both gouache and watercolour, you will need thick watercolour paper (thinner paper stretches when wet and dries in a warped shape), and a range of brushes – large and small round brushes and a square brush are good starting points. If you enjoy using paint then experiment with other options: acrylic paints are also water-soluble but they dry with a tough, rubbery texture, so are good for use on surfaces other than paper. Oil painting is best done on canvas and requires specialized solvents, so may be a bit daunting (and expensive) for beginners, but it is certainly fun to explore.

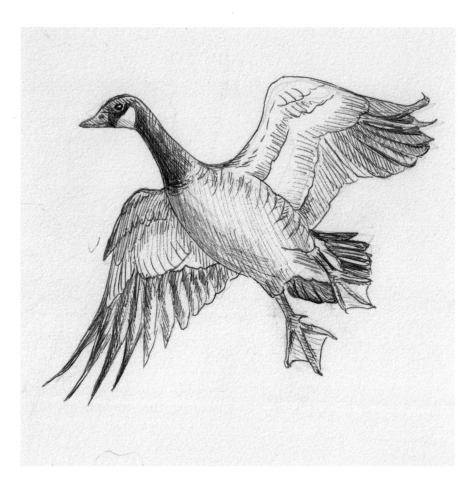

Hatching and blending

Ink pens are designed for clean, precise writing and so lend themselves to drawing with crisp lines. To create shading you can draw fine parallel lines (hatching) for lighter areas of tone and criss-crossed lines for the darker areas (cross-hatching). Both hatching and cross-hatching can be built up by adding more sets of lines, as in this biro sketch of a Canada goose.

You can use pencils for hatching too, but they also allow for more flexible techniques. Those with softer leads (grades B, 2B and higher) can easily be used to create shading through varying the pressure you apply, and if you use the lead on its side you can shade larger areas at a time. You can also use your fingers to smudge or blend the shading, though this tends to create a rather muddy effect with lead pencils. Blending works better with pastels, pastel pencils and coloured pencils, allowing you to create new shades by working over one colour with another.

White on black

Using light colours on tinted or black paper, as in this sketch of a great white egret, is a great way to change how you look at light and understand how it gives your subject solidity. You can buy dark paper and draw on it with pastels or pastel pencils, or if you are painting you may choose to create a dark background by painting it in first, and then using white and pale paint to pick out your subject.

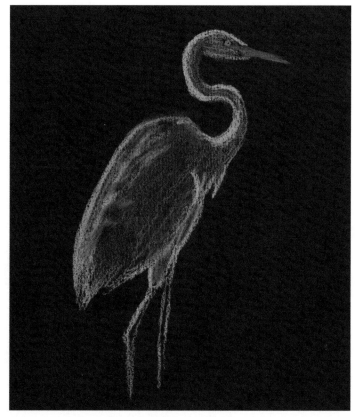

Painting techniques

A glance around any art gallery reveals the huge array of different painting techniques and styles available to us. Experimenting with techniques is great fun, with different media best suited to different methods.

To create fine detail, as in this gouache painting of a crested tit, you will need to use fine brushes with paint that isn't very diluted. Using a larger brush and wetter paint mix allows you to work more quickly and with more freedom. This is a good way of creating initial colour 'washes' before adding detail, and you can use masking fluid (which dries and can later be rubbed off) to keep some areas paint-free if you wish. However, you can also stick with wet paints and a loose style to complete the painting if you are after a softer and more impressionistic look. You can blend paint colours on a palette but with watercolour in particular you can also blend them on the paper by allowing wet washes to meet each other. It is harder to control the outcome in this way, but the results are often very striking and beautiful.

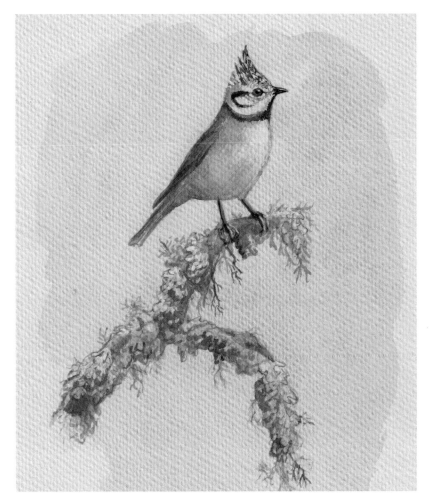

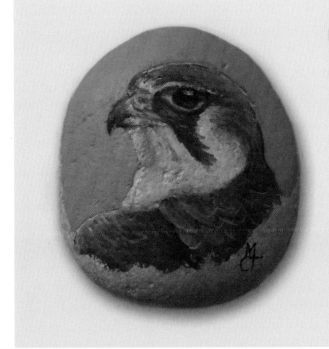

PEBBLE-PAINTING WITH ACRYLICS

To paint on surfaces other than paper you will usually need acrylic paints rather than gouache or watercolour. Painting on pebbles is a popular hobby. You can buy suitable flat pebbles at craft shops, and a good starting point is to try a set of acrylic paint pens, as these allow you to draw just as if you were using an ordinary pen. For more detail, as in this portrait of a lanner falcon, fine brushes give even more control and also make it easier to blend colours. Acrylic paints are opaque so it is easy to overpaint mistakes once the paint dries (which does take a while). To protect your finished creation from wear and tear, add a couple of layers of fixative spray.

General hints and tips

All bird drawings have certain elements in common. The following hints and tips are well worth bearing in mind as you plan your composition, and when you come to add detail.

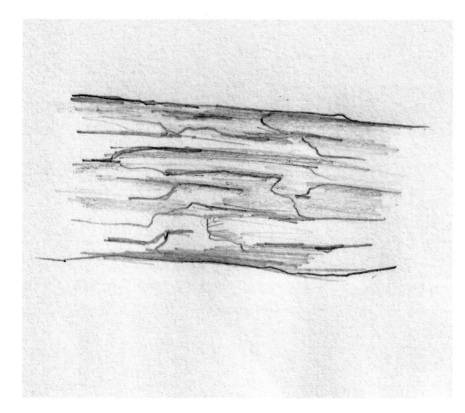

Backgrounds

You may wish to draw just a bird with nothing else in the picture, and this is easy enough to do (especially if the bird is flying!). However, if your bird is perched on a twig, for example, you'll probably want to complete the twig to a suitable level of detail. It's therefore worth taking some time to look at techniques for drawing and painting possible background elements, such as bark on a twig as shown here, parts of a tree, grass, leaves, rocks, water and clouds. Everything has its own particular texture and, as we shall see with feathers below and on page 36, there are techniques for creating the right appearance. Bark, for example, can be shown with a 'shorthand' pattern of jagged parallel lines against a roughly shaded background. You may find it helpful to build a library of reference photos to use for various types of background.

Textures

A bird has a variety of different textures over its body, from its various feathers to the unfeathered parts of legs, bill and eyes. The texture of a surface is conveyed in how it reflects light. Very smooth surfaces, like an eye, are highly reflective and often show clearly focused light spots, while bills and claws are a little less smooth so reflect light in a more diffuse manner. Feathers are highly variable in apparent texture – some look very smooth and glossy, while others are rough and soft like fur and their patterns of light and shadow are much more subtle and graduated.

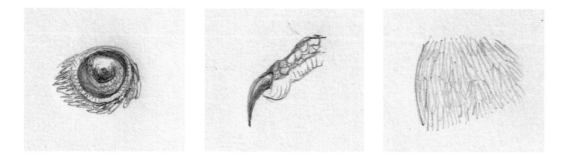

Proportions

Getting the proportions even slightly off can make a beautifully detailed and carefully finished drawing or painting look simply 'wrong', so it is always worth taking lots of care when composing your initial sketch to make sure that all the parts of the bird are the right size relative to each other. This also goes for the size of the bird relative to its surroundings. A very common mistake is to make the bird much too large compared to other objects in the image – for example, a small bird among foliage, with the leaves shown at a tiny size relative to the bird. As this quick sketch of a goldcrest on a leafy branch shows, the bird is no larger than the individual leaves of the tree in which it is sitting, and the same goes for many other small birds.

Perspective

Our brains have figured out many ways of seeing our world in three dimensions. We know that objects shrink in apparent size as they recede from our viewpoint, and we know that when we look at a landscape of hills, the closer ones overlap the further ones, and the more distant ones appear paler than the nearer ones. One of the most striking of these depth cues is the convergence of parallel lines – imagine looking down the length of a train track – a phenomenon known as linear perspective. Perspective also affects the apparent shape and size of a bird's wings when one wing is closer to you than the other; this is known as foreshortening. You may make use of one or more of these cues in your bird drawings to give an extra sense of three-dimensional space.

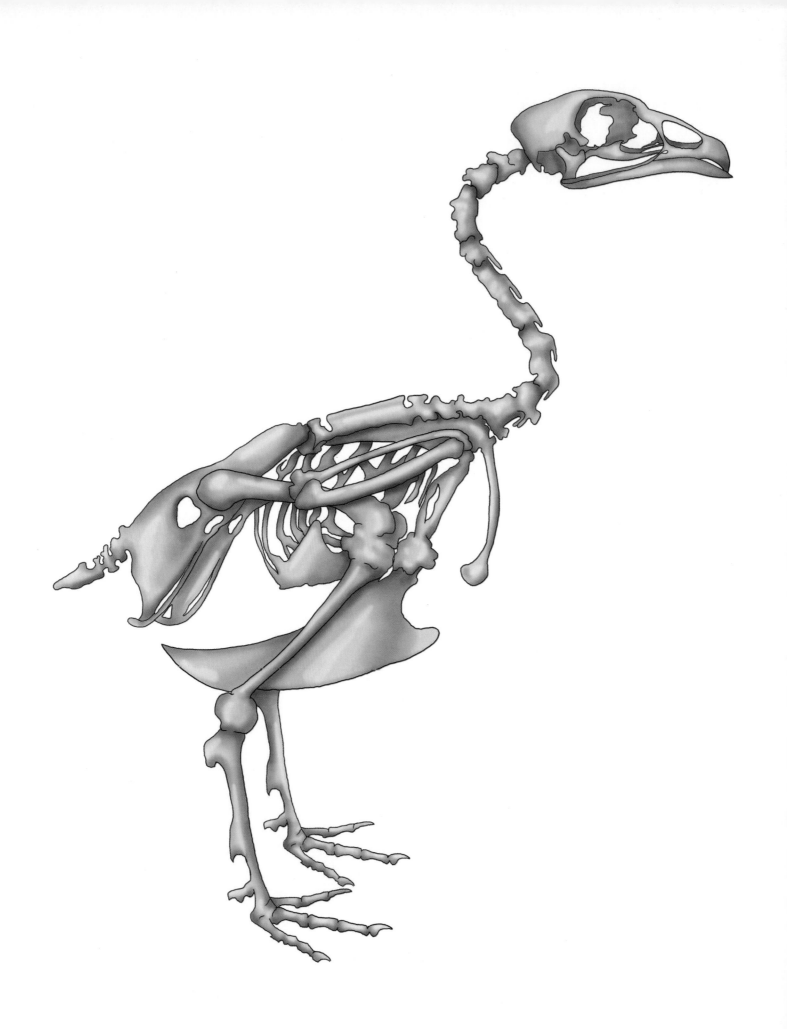

Chapter 1

Bird Anatomy

Before you start drawing birds, it is a good idea to familiarize yourself with their structure and proportions and how the various parts of their anatomy interconnect. Close study of their distinguishing features – eyes, bills, feet and feathers – will also stand you in good stead when you come to follow the step-by-step exercises in Chapters 2–4.

Birds, like us, are vertebrates and tetrapods – that is to say that they have an internal skeleton made of bones, and they have four limbs. A bird's skeleton is not nearly as different to our own as outward appearances might suggest. It has a skull and a spinal column, a ribcage, sternum and pelvis, and its limbs have long bones and flexible joints. There is one bone between shoulder and elbow (the humerus) and one between hip and knee (the femur). Two bones (the ulna and the radius) connect the elbow to the wrist, and two more (the tibia and the fibula) join the knee to the ankle. The digits are formed by small bones called phalanges.

The main differences we see are in the relative proportions of the bones and their shapes. Birds also have smaller, lighter and fewer bones than we do, with some missing completely (such as most of the 'finger' bones) and others much reduced in size, or fused together. The spine is relatively short, not extending into the tail. Birds' tails are made of strong feathers, so they are not flexible like a lizard's tail. These are adaptations to a life on the wing, for which the body needs to be lightweight.

If we put muscles and skin on our bird skeleton, we can still see the similarities between its four-limbed shape and ours. However, once the bird is clothed in its coat of feathers (its plumage), it becomes a very different creature. The plumage gives it a whole new shape, smooth and streamlined, and disguises many of the features that reveal it to be our tetrapod cousin.

The skeleton of a bird is a study in optimization. Evolution has trimmed down the bones to the bare minimum, to create a super-lightweight supportive framework, which makes the work of taking off and flying much easier. The bulk of a bird's body comes courtesy of its coat of dense (but also super-lightweight) feathers.

Bird body plans

Identifying and marking down the simplified geometric shapes of a bird gives you a central structure, around which you can build up its characteristic features. The size and placement of these first shapes is important and it varies widely between different species. Here we focus on birds seen in a straightforward, side-on view.

Step 1

To draw a bird's outline in a side-on view, start with two oval shapes – a large one to represent the body and a smaller one for the head. Depending on what species of bird it is and the posture it is in, the ovals may be separated (by a length of neck, which you will add later!) or very close together, perhaps even overlapping. This bird outline is of a passerine, of no particular species. Passerines are the bird group that contains all of our familiar small songbirds, such as sparrows, finches and thrushes.

Step 2

Connect the head and body with smooth concave lines. Add the bill – a simple triangle at the nine o'clock position on the head oval. Add the wing, noting that it fits snugly to the body. The visible joint of the wing, forming the point where it bends, is the equivalent of the human wrist, not the elbow (which is why it bends backwards).

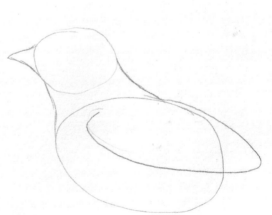

Step 3

Add an oval for the eye. It is slightly forward of centre on the horizontal plane, and more or less lines up with the centre of the bill on the vertical plane.

Add the wingtip (a triangle formed by the folded primary flight feathers), and the tail. In most small birds the tail reaches well beyond the wingtip, but in a few (and in many larger birds) the tips of the wings and the tail stop at about the same point, and sometimes the wings are even longer than the tail.

Add the legs and feet. The visible joint is the equivalent of a human ankle, which is why it bends forwards. The knee joint is entirely hidden in the feathers, and (with smaller birds especially) sometimes the ankle joint is too. In most birds, the foot has four toes, and the 'big toe' is rotated backwards. Each toe bears a curved claw. Legs and feet are often larger than you might think, relative to the size of the bird.

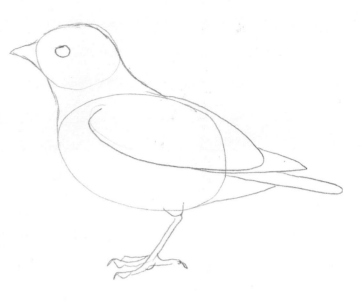

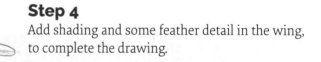

Step 4

Add shading and some feather detail in the wing, to complete the drawing.

Posture and feather position affect how we begin our drawing. Feathers can lie flat to the skin, or be fluffed up. The former creates a sleek outline, the latter a rounder and fluffier shape. Birds may also stand up tall or be more hunched up. This house sparrow is drawn in a compact, fluffed-up and hunched posture, so its head and body ovals overlap.

Slender

The killdeer, a wader or shorebird, has a slender outline. It has a much longer neck and legs, and shorter tail, than the house sparrow, so there is a good space between its head and neck ovals, and its ankle joint and the leg above are both clearly visible.

Long legs

Large, long-legged birds like this kori bustard have a robust build and proportionately small heads. They often hold their bodies more upright than smaller birds when resting and walking.

Bird body plans – variations

There are about 10,000 different species of birds in the world, which makes them considerably more diverse than the other tetrapod groups – mammals, reptiles and amphibians. However, in terms of fundamental anatomy, they are much *less* varied than the other groups. All birds have two legs and two wings, all have a bill and no teeth, and all have a body covering of feathers. Mammals in particular show much more diversity of form – bats and whales confused the world's first biologists for hundreds of years, as did the platypus, echidna and pangolin – but every bird is unmistakeably a bird.

Nevertheless, birds have proved incredibly successful in evolutionary terms, and make their living in many different ways in all kinds of different environments. We looked at some land birds on the previous pages, adapted to hop, perch, walk and run, as well as to fly. The bird world also includes swimmers and deep divers, birds that can wade in deep water, and those supremely adapted to an aerial existence – for them flying is an almost permanent state of being.

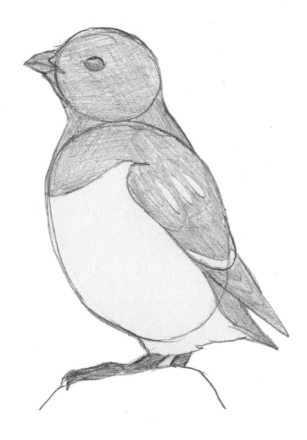

Auks and penguins

Seabirds find their food at sea, and many only come ashore to breed and are built for long, effortless flights. At the other end of the scale are the penguins, which have dispensed with aerial flight altogether and instead use their wings to 'fly' underwater, going deeper and staying submerged for longer than any other bird as they chase fish and squid.

Auks replace penguins in the northern hemisphere and have a similar compact, streamlined shape. They can still fly, but also swim underwater using their wings. This little auk, as with many deep-diving birds, has its legs set towards the rear of its body. This means that it stands very upright.

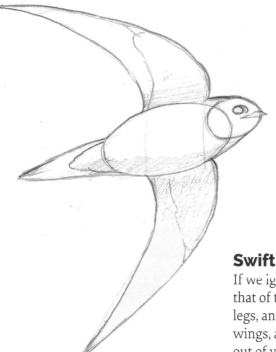

Swift

If we ignore the wings, the body shape of the common swift is similar to that of the little auk, although less chubby. It has a very short neck and legs, and a tiny bill. This streamlined shape, together with its long, narrow wings, allow it to fly quickly and with minimal effort. The feet are tucked out of view under the feathers, to keep them warm. When drawing a flying bird from the side, note that the bases of the two wings are parallel (see Chapter 3 for more on birds in flight).

Flamingo

In dramatic contrast to the super-streamlined auk and swift, the greater flamingo is as gangly and lanky as a bird can be. A flamingo's neck and legs, proportionately the longest in the bird world, enable it to feed in relatively deep water without swimming. It puts its head into the water upside-down when it feeds, filtering out tiny organisms using its oddly shaped bill.

The body and (much smaller) head ovals here need to be spaced well apart, as the neck is nearly as long as the legs. Note that the neck is about the same thickness along its whole length, rather than wider at the base as in long-necked mammals like horses and giraffes.

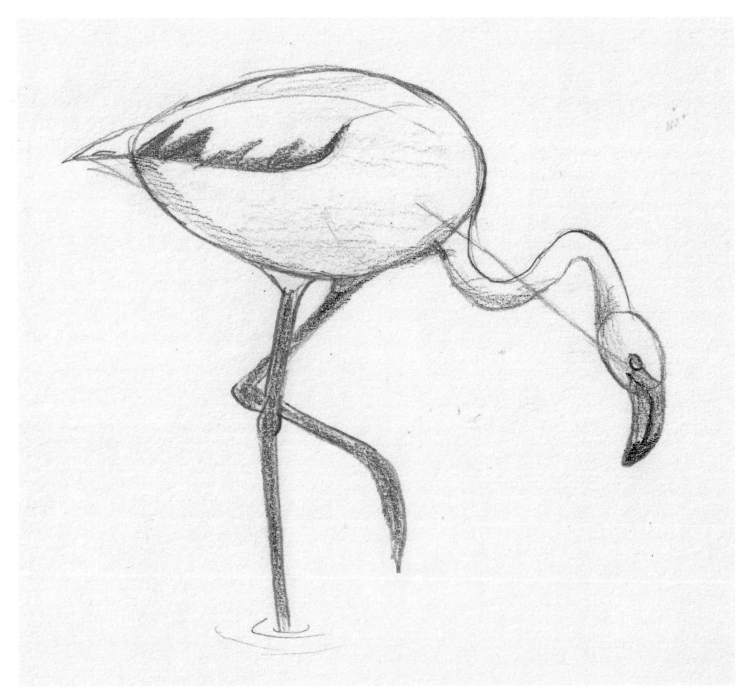

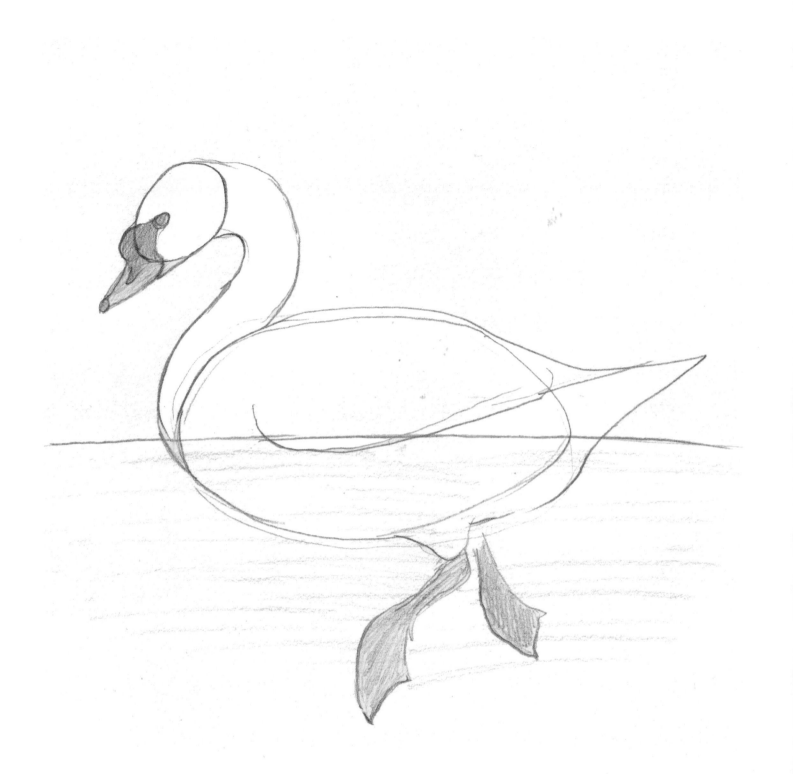

Swan

Like the flamingo, the mute swan has a proportionately long and curvy neck, but it also has the short, strong legs and webbed toes of a swimmer. The bird is drawn on the water but with its entire body in view, to show that it has the same oval shape as other bird bodies, rather than resembling a flat-bottomed boat.

Heads and expression

When we look at an image of an animal, we focus on the head and the eyes first, as we are adapted to read facial expressions. It can be more difficult for us to feel an emotional connection to an animal that doesn't have the same sorts of facial features as we do. Birds have bills rather than lips and noses, and in many species the eyes are side-facing rather than front-facing so we only see one of them at a time. However, we do still find great expressiveness in their eyes and bills, and the way they raise or lower the feathers on their heads.

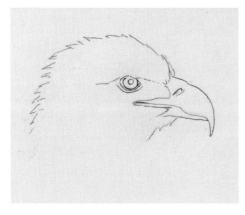 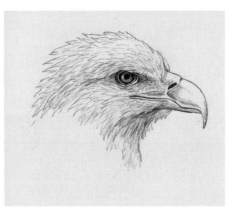

Birds of prey

Birds of prey like this bald eagle look like they are frowning, because of the ridge of feathers that shades the eye. This, with the hooked bill, gives an intense expression. The nostril is set in a fleshy cover (the cere) over the base of the bill, and that the bare skin around the line of the mouth (the gape) extends a long way back – even beyond the eye in some cases.

Bare skin

The male common pheasant has an area of bare red skin on its face. Often, colourful bare skin on the face becomes puffed up and more intense in colour when the bird is excited (for example, during a courtship display).

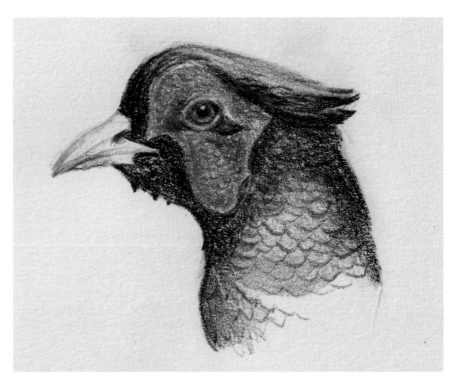

Mood

Mood affects the position of the head feathers, and the resultant expression. A common raven has loose, ruffled plumage when relaxed, while an alert bird displays smoother, flattened plumage.

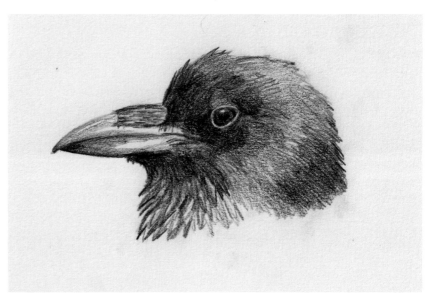

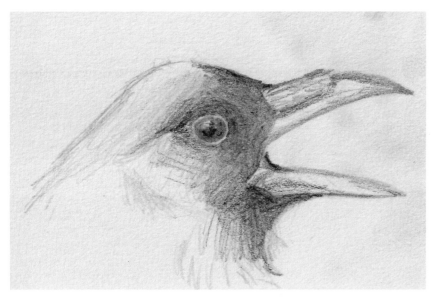

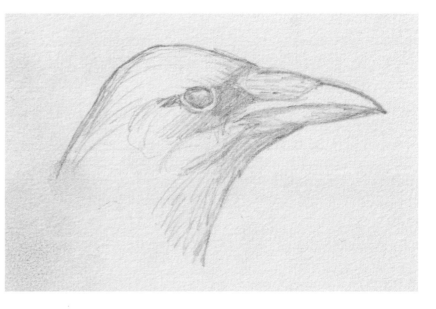

Drawing a bird's head

When doing a study of a bird's head, such as this song sparrow, begin with the basic oval shape and then position the eye and bill carefully. In this particular species, the line where the upper and lower parts of the bill meet is not straight but has a distinct kink near the base of the bill. Many passerines in particular have variations on a similar pattern on their heads, and the markings follow the lines of feather growth (tracts). Sketch out the lines that separate different feather tracts on the crown, cheek and throat and around the eye, before adding shading.

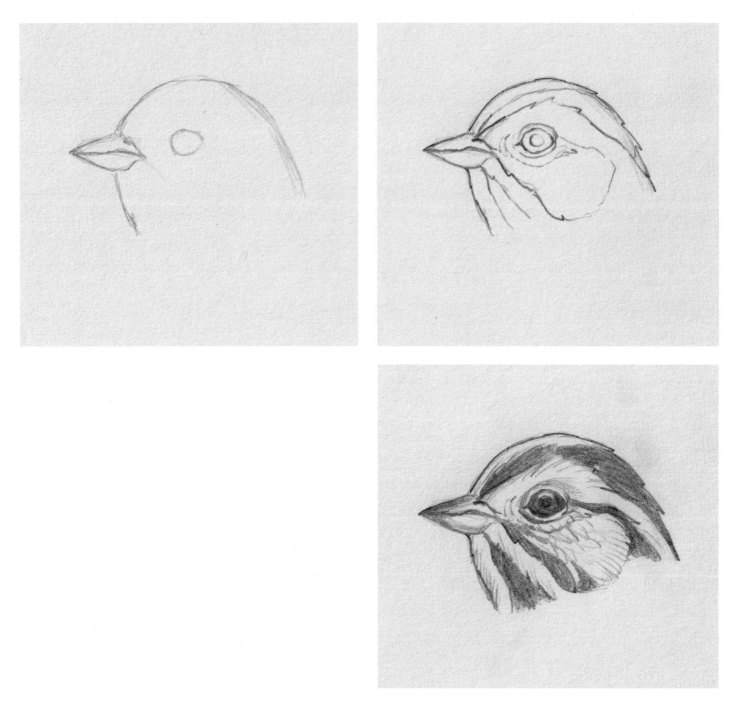

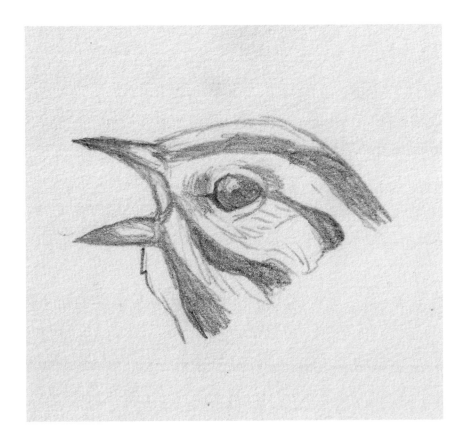

Note that the song sparrow's cheek stripe begins where the top part of the bill meets the head, and the throat stripe begins where the bottom part of the bill meets the head, when seen in a bill-open pose.

Drawing a bird's head in a front-on view is difficult, because of the foreshortening (imagine trying to draw a sword looking at it directly from the tip!). Paying careful attention to the position of markings helps to define its shape.

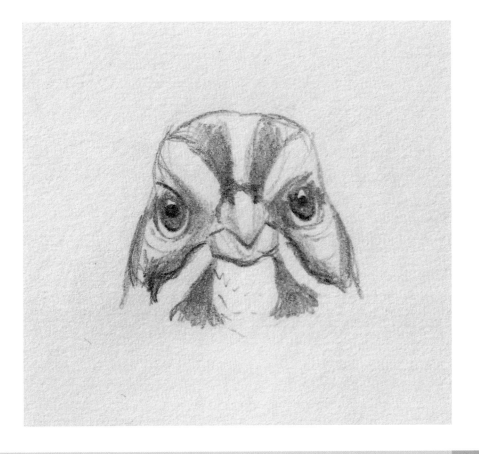

Heads in detail

A detailed study of a bird's head begins with the basic oval shape and then careful observation of how the bill works with the head shape.

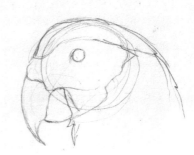

Steps 1 & 2

Begin with the outline of head and bill. Remember that the bill is part of the skull and so forms part of the continuous shape of the head – this is particularly evident in parrots, such as this blue and gold macaw. The bill contrasts in colour to the rest of the head which can make it look like a stuck-on extra, but underneath its thin covering of coloured keratin, it is a bony projection of the skull, like our nose and jaws. Note that the curved line of the upper part of the bill forms a segment of an almost circular line when added to the curve of the neck and head.

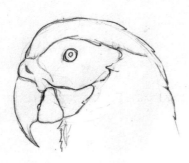

Step 3

Add detail to the two parts of the bill, then position the eye, nostril, and the area of bare, white skin that covers most of the face.

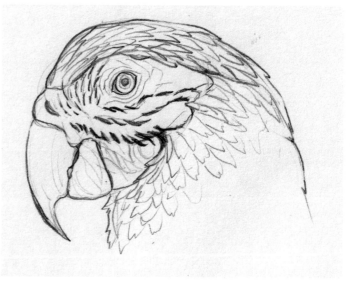

Step 4

Add feather detail, noting the lengths of the feathers and the direction in which they lie. They are smoothed back against the crown and cheek, a little looser on the throat, and become longer further down the head.

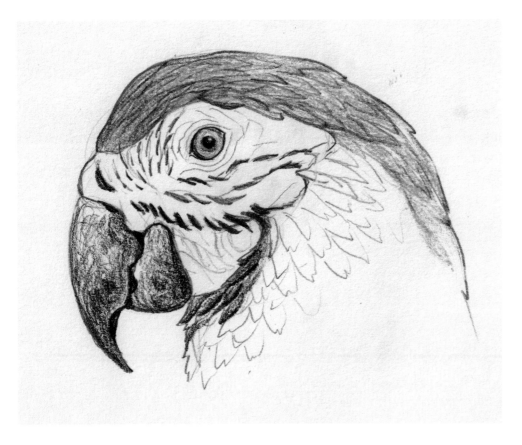

Step 5
Begin to add colour, merging green into blue on the front of the crown, and shading in the eye and bill. Parrots' bills take a lot of punishment in their day-to-day life and so their keratin coating often shows uneven patches of wear.

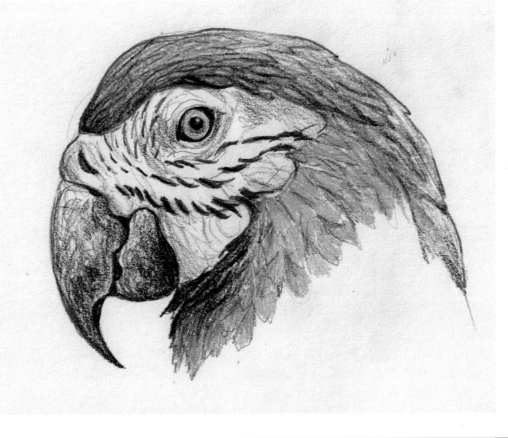

Step 6
Complete the drawing by adding the remaining colour to the feathers on the face, using darker shades to create shadow under the bill and around the tips of feathers where they overlie the feathers below.

Woodcock

With a very long bill and eyes positioned close to the top of its head, the Eurasian woodcock has a very distinctive facial look.

Puffin

The horned puffin and its close relatives are sometimes nicknamed 'sea parrots' because of their large bills. When drawing the head front-on, remember that the bill will look very narrow but will take up almost the whole top-to-bottom span of the face.

Bald heads

Observing and drawing a bald-headed bird, like this turkey vulture, gives you the chance to see how the skin folds around the shape of the skull. The ear opening, just behind and below the eye, may also be visible, depending on the position of the skin folds.

Eyes

Birds' eyes are much like our own. The visible part, protected by a transparent, dome-shaped layer (the cornea), is a coloured, round iris with a central hole (the pupil). Light passes through the pupil, which becomes bigger or smaller depending on light conditions. However, birds usually show little or no visible sclera (the white of the eye, that covers the rest of the eyeball). The shape of the visible part of the eye is close to circular in most bird species. The eyelids are usually bare or sparsely feathered, and when the eye is wide open they appear as a narrow ring of skin, which may be a bright, contrasting colour. The feathers around the eye are typically very small and short. There is often a more or less prominent feathery ridge above the eye to provide protection from sunlight.

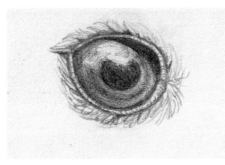

Iris
Most birds have a dark brown iris, with a slightly darker circle of colour just outside the pupil. You'll usually see an obvious spot of reflected light – a highlight – on the eye. Remember the eye is dome-shaped, so light coming from above will reflect off the upper surface. The highlight may be a single small, bright point or a more diffuse, larger area, depending on the light source.

Lower eyelid
In most birds, including this sand martin, a blink or closing of the eye involves the lower eyelid moving upwards to cover most of the eye. Notice how the highlight reduces in size as the bird's eye narrows, but does not disappear.

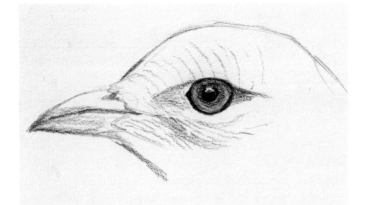

Eye colour
All kinds of eye colours exist in the bird world, although the most common are dark brown and pale yellow. Vivid colours, such as the vibrant blue-violet of the satin bowerbird, make for a very striking appearance.

Step 1

When drawing the eyes of an owl, such as this southern white-faced owl, note that the space between them is about the same width as one eye.

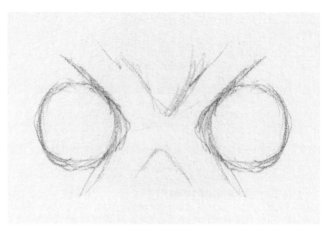

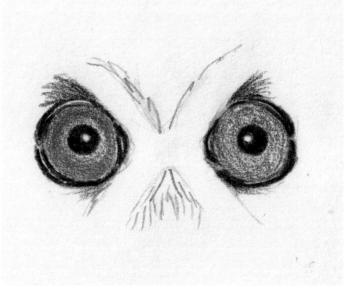

Step 2

Many owls have black eye-rings, with the eyes themselves set in an arc of dark feathering, creating a very intense expression.

Step 3

Although the highlight in the eye usually falls on or above the pupil, the brightest and lightest part of the iris is below the pupil.

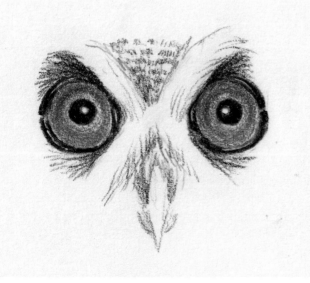

Step 4

Adding shading to the feather detail around the eyes completes the face of this very striking-looking owl.

Bills

Birds' bills are often their main tools for interacting with the world, as well as their means of dealing with their food. Depending on the species, bills may bear hooks, serrations, tooth-like projections, or have the capacity to flex and bend. They may be used to seize, crush, dismantle, tear, filter, probe or snip. They are also vital for more creative and more delicate operations, such as crafting a nest, keeping the plumage (and perhaps also the plumage of a partner or close friend) in good condition, and carefully feeding their tiny and helpless chicks. It's no surprise that bills show such incredible variation in form and function.

Step 1

The Australian magpie has a simple but strong, sturdy bill. Note how the feathering extends down the length of the bill just above the mouth, and under the chin.

Step 2

A paint wash provides the basic blue-grey colour of the bill.

Step 3

Many birds have darker coloration at the tip of the bill and along the point where the two halves meet, and around the nostril. In most species the nostril is slit-shaped and positioned close to the base of the bill.

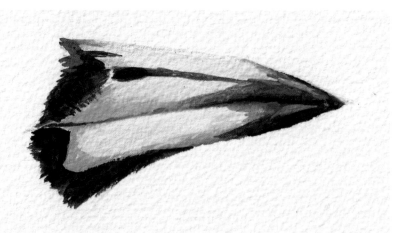

Step 4

The painting of the bill is completed with feathers around the base, darker tints to the coloured parts, and highlights in the brightest areas.

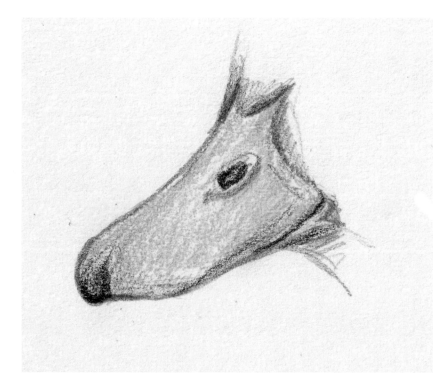

Ducks

Most ducks have quite long, round-tipped bills, with the upper part covering most of the lower part when the bill is closed. Often the bill is brightly coloured (yellow in the case of the male mallard shown here) with a dark, hard growth at the tip called a nail.

Tubenoses

The group of seabirds known as 'tubenoses', which includes this northern fulmar as well as storm petrels and albatrosses, have complex bills with tubular nostrils.

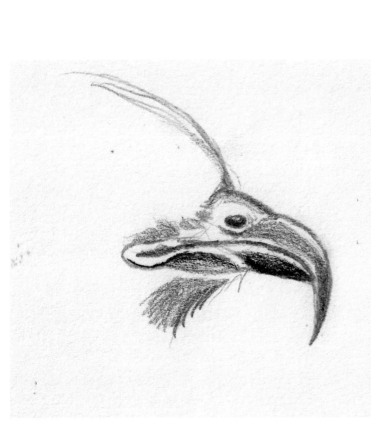

Spoonbill

The roseate spoonbill sports a very unusual bill, which it uses to filter small creatures from the water in which it feeds.

Birds of prey

This snail kite shows all the typical features of a bird of prey's bill: nostril set in a fleshy cere at the base; a fleshy surround to the line of the gape as it extends backwards; and a hooked tip. This species has a particularly long and delicate bill hook, which it uses to extract snails from their shells.

Feet

The legs and feet of birds show their evolutionary heritage very clearly – it is easy to imagine dinosaurs striding around on super-sized versions of scaly chicken legs. The shapes and proportions of the legs and feet vary depending on how the bird gets around when not flying, and in some cases the feet are also used to catch, carry and process food. Birds that use only their bills to deal with food often have simple and proportionately tiny legs and feet.

In most birds, the visible part of the leg comprises the ankle joint (not to be confused with the knee which is higher up and usually hidden beneath feathers) and the tarsus, which connects the toes to the ankle joint and is often quite long. In very long-legged birds there is often a length of tibia (equivalent to the shin) visible above the ankle joint.

The vast majority of birds have four-toed feet. The first toe (analogous to our big toe) usually points backwards, while toes two, three and four point forwards, with the middle (toe three) being longer than the other two. In larger birds that live mainly on the ground and get about by running, the hind toe is often very reduced in size and may be absent altogether. However, small running birds often have long hind toes and claws, which may help give extra purchase on rough grassy ground. Each toe is tipped with a claw, and claws vary considerably in size and shape, from broad, short and blunt in many ground-dwelling and swimming birds, to long and curved in passerines and birds of prey.

Webbed feet

A full-length membrane of webbing between the three forward-facing toes turns a duck's foot into a highly effective paddle. Besides the ducks and their relatives the geese and swans, several other groups of birds have similar webbing, including gulls, penguins, divers and petrels. Variations include the coots and grebes, which have fleshy lobes rather than full webbing. In cormorants and gannets, the hind toe is much longer than in ducks and is connected to the first toe with an additional web. Some wading birds, such as avocets, have a small amount of webbing at the toe bases only.

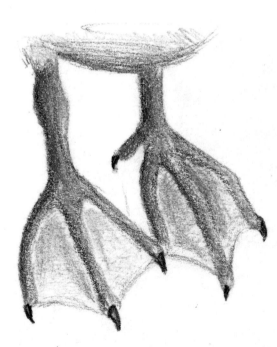

Birds of prey

Birds of prey such as eagles use their feet to grab and restrain their prey, so they have sturdy toes and long, curved claws (often called talons). The tarsus is often feathered rather than bare.

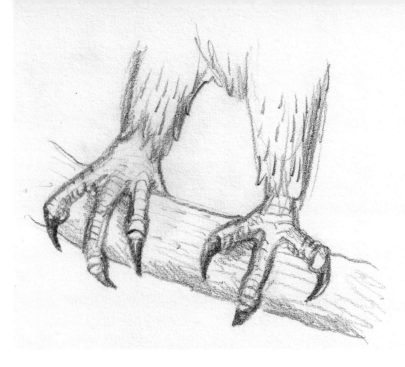

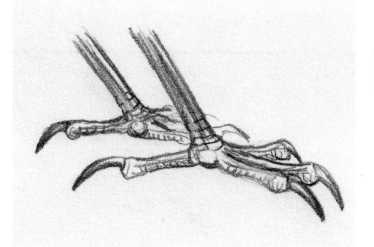

Passerines

A typical passerine foot has long, slim toes and curved, pointed claws, adapted for gripping branches and other narrow perches.

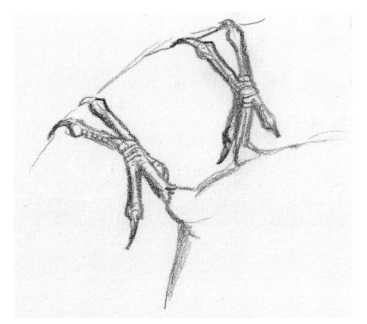

Climbing feet

Woodpeckers, parrots and a few other birds that spend much time climbing among tree branches have the fourth toe rotated backwards. This two-back, two-forwards toe arrangement provides an extra-secure grip.

Feathers

The feather is a miniature marvel and having a full body covering of feathers (plumage) is the secret to birds' tremendous evolutionary success. The first feathers, developed from reptilian scales, grew on the bodies of dinosaurs and their soft, hair-like structure helped trap heat close to the skin. In modern birds, feathers form a smooth, weatherproof shell, on which an amazing variety of colours or patterns may be displayed, with a soft and fluffy underlayer. Hair-like feathers around the mouth and eyes provide tactile sensitivity, while the tail and wings have long, sturdy but somewhat flexible flight feathers that, when spread, provide the air resistance needed for flight.

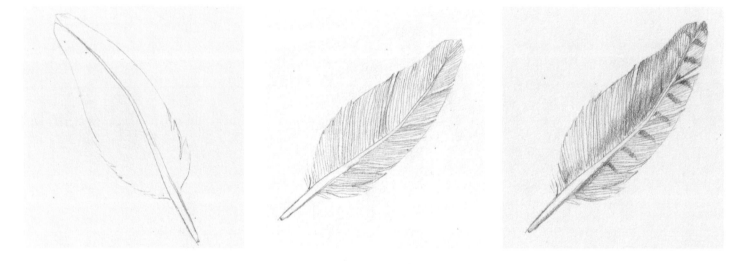

Feather structure

A feather consists of a central shaft or rachis, which is hollow and made of lightweight keratin. The rachis is very strong in larger feathers. On either side, in two separate vanes, grow the side branches, or barbs. These have small side branches, called barbules. The barbules interconnect, forming a continuous surface. It is easy to separate two barbs, but also easy to smooth them back into place, which is what birds are doing when they preen their feathers. Even in large flight feathers, the barbs at the very base of the rachis are soft and fluffy and don't hook onto their neighbours. These fluffy, downy parts sit very close to the bird's skin and help hold warm air against the body.

Contour feathers

Most of the feathers on a bird's body are the contour feathers that form the outer shell. They are rounded in shape, with the two vanes roughly the same width. They have a smooth surface with some fluffy barbs close to the base of the rachis, and they sit in overlapping arrangements on the body.

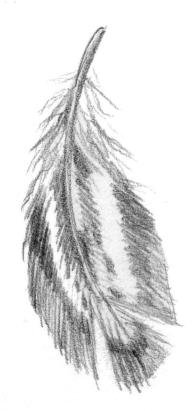

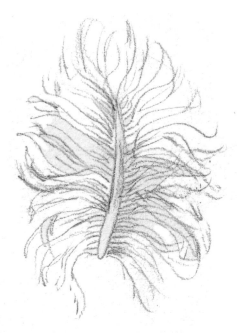

Downy feathers

In addition to the fluffy bases of contour feathers, birds also have tiny feathers that are entirely downy. They have a soft, bendy rachis and all of the barbs are soft and loose. These feathers are rarely visible as they lie underneath the contour feathers, but they add volume to the bird's shape.

Flight feathers

A bird's wing has a row of long outer feathers, known collectively as flight feathers or remiges. The outermost ten, attached to the equivalent of the human hand, are called primary feathers, while the shorter, innermost set (anything from nine to 25) on the 'arm', are secondaries. When the wing is fully spread, these feathers work as individual aerofoils, like a plane's wing, while also forming a single aerofoil shape. One vane is much narrower than the other, and in larger primary feathers there is often a distinct notch near the tip, which enables more precise control in flight.

The long feathers of the tail are called rectrices, and are arranged in pairs – usually five or six pairs in total.

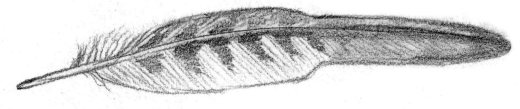

Feather tracts

Feathers grow in distinct grouped patterns called feather tracts. They are most obvious on the wing, because these are the largest feathers on the body in most birds. Elsewhere, the tracts are harder to discern, although often their pattern is revealed by the colours or markings on that part of the body (for example, by lines on the belly or back). The positions of the feather tracts are broadly the same across different bird families, but there are some differences because birds vary a lot in the total number of feathers they have, as well as the relative sizes of the feathers.

A diagram that shows the parts of a bird, including the most obvious feather tracts, is known as a 'bird topography diagram'. You will often find these at the start of a bird field guide, because understanding feather tracts can help with identification. This understanding is also very helpful when you are drawing birds, showing how the different parts fit together when the bird is in different positions (for example, the way the flight feathers fold up, and the arrangement of the smaller wing covert feathers that lie on top of them).

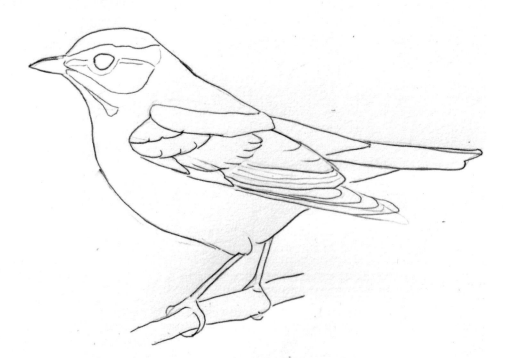

Small birds

Small birds have fewer feathers than larger species, so the different parts are easier to discern. The different facial feather tracts often bear distinct contrasting markings.

Markings in flight

In flight, the tracts of the wing feathers on a bird of prey are clearly visible. The overlapping sets of wing covert feathers contribute to making the wing shape thicker on the leading edge, providing it with an aerofoil shape, like an aeroplane wing, which helps generate lift.

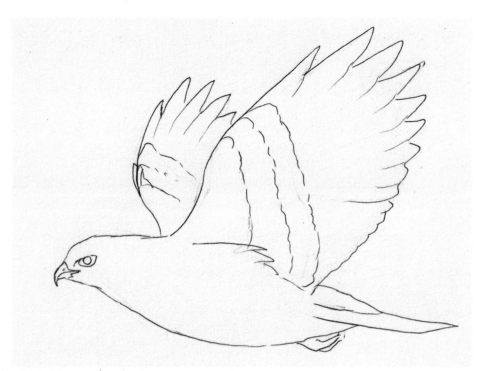

Larger birds

The wing feather tracts have a different appearance on larger birds, such as shorebirds, with more feathers forming each group.

Tail feathers

When viewed from above, the central feathers of a bird's folded tail are on top. If viewed from below, it is the outermost feathers that are most visible.

Feathers – unusual examples

Feathers have many different functions, but it is their function as decorative objects that is perhaps most appealing to the artist's eye. Their colours cover the entire visible spectrum. Some of these colours are the result of pigmentation (the presence of dark melanin, or red and yellow carotenoids). Others are created by a special microstructure that bends light waves to create dazzling iridescent shades. The more muted colours of birds with well-camouflaged plumage are no less impressive in their intricacy of tone and pattern.

Colour is not the only way that feathers can impress, though. In some species they have evolved into remarkable, elaborate shapes and sizes, often for the purposes of courtship or territorial display. These feathery ornamentations may be raised or lowered, fanned out and shaken about, or allowed to whip in the wind as the bird flies – all ways of catching the eye of a rival or a potential mate.

In some bird groups, the entire plumage has a different look to that of more typical birds. For example, the ratites (flightless and mainly very large birds, including ostriches) have loose, hair-like feathers, while penguins have exceptionally thick and dense, smooth-surfaced plumage to insulate them in deep, cold waters.

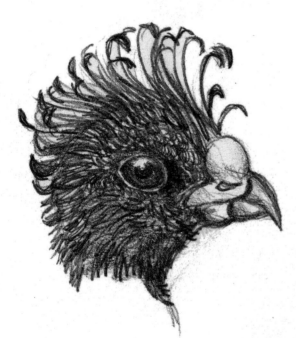

Crests
Many birds sport head crests. The loose, dramatically curly head plumage of the male great curassow is a striking example.

Plumes
The male greater bird of paradise shimmies and shivers his waterfall of soft yellow-white plumes during courtship. The display is formed by greatly elongated flank feathers.

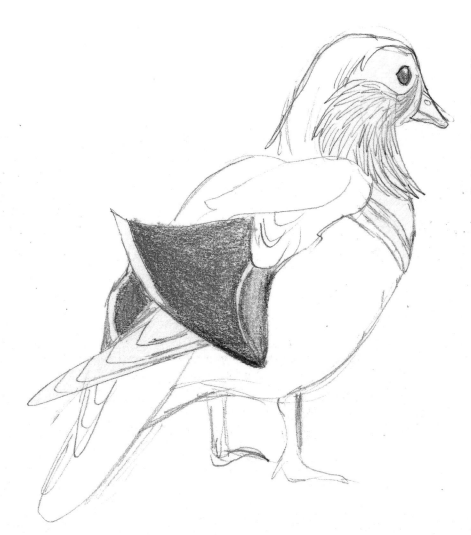

Sail feather

This sketch of a male mandarin duck shows the remarkable 'sail' feather – a single super-sized inner flight feather that stands up from the wing. The mandarin also has very elongated crown and cheek feathers, forming a long crest and a fine set of 'whiskers' respectively.

Fluffy feathers

Kiwis are members of the ratite group of birds, and although much smaller than the related ostriches and emu, they have a similar feather structure. The barbs of the feathers do not 'zip' together and look more like fluffy fur. With bodyweight less of a concern for these flightless birds, having a dense, shaggy plumage helps them to keep warm and protected from scratchy vegetation as they forage through the undergrowth by night.

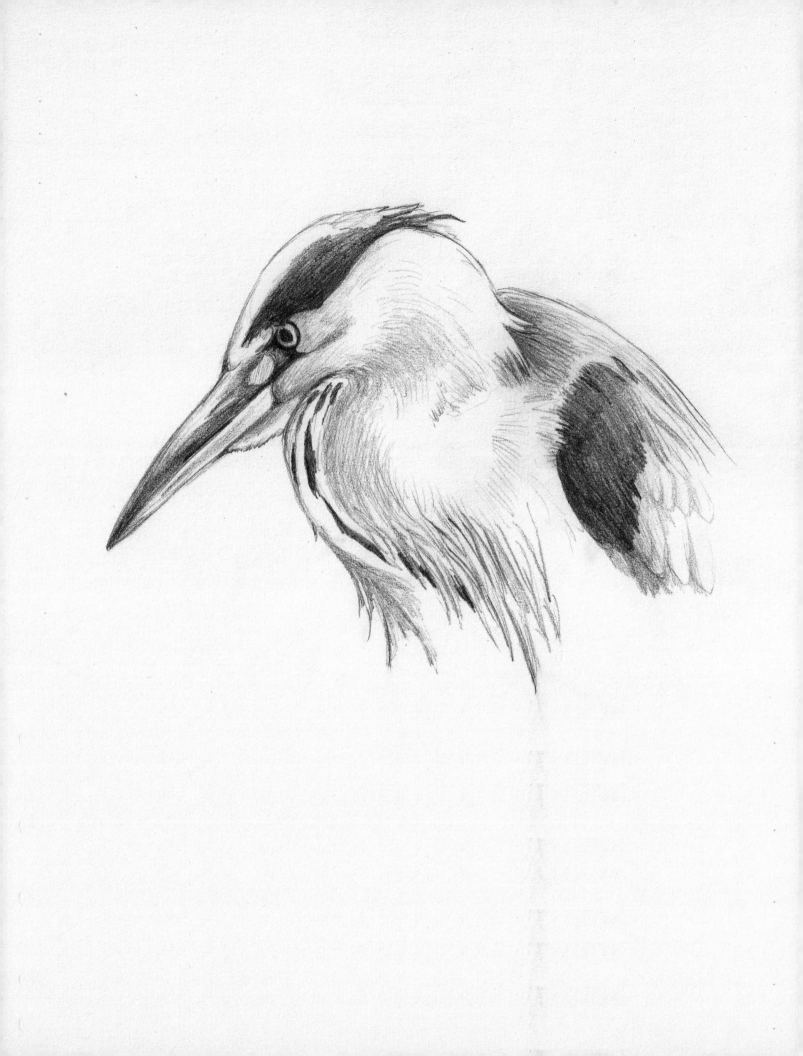

Simple Poses

When you are setting out to complete your first bird artworks, you'll have an easier time if you draw your subject in a straightforward pose: side-on, with wings folded and legs in a relaxed posture (or, even better, hidden completely!). All of the artworks in this chapter are of birds in these relatively simple poses. They are either perched, standing or walking on the ground, or swimming on the water's surface.

Whether you are aiming to produce a quick drawing or a complex painting, it's always a good idea to begin your piece with a light pencil sketch, using a fairly hard pencil (HB or H, perhaps). Use the techniques shown in Chapter 1 to create the basic outline, and then erase positioning lines that you don't need. Taking time and care to get the sketched outline right is always worthwhile; it is disheartening to invest hours in a piece only to realize that your subject's fundamental shape or proportions are not quite right. We start this chapter with exercises that are completed entirely in pencil, progressing on to works in coloured pencil and finally to paint.

Spend time looking at a range of images of the bird species you want to draw (or, even better, watch it in real life), to familiarize yourself with how it tends to perch, stand or float. You'll soon notice consistent differences between apparently similar species. Flycatchers usually perch in a more upright position than warblers, for example, and ducks that dive float lower on the water than ducks that only dabble. Noting and replicating the quirks of posture that you might notice, such as wrens' habit of cocking their tails up vertically, or cuckoos' tendency to droop their wings, can help give your bird drawings the right character.

PORTRAITS

A portrait is any representation in which the face is prominent – usually it refers to an image of a person that shows the head and shoulders only. Birds, when they keep still, also lend themselves to portraiture, although you need to be careful with composition. In particular, consider how far down the body you take the image, to make sure that it looks natural rather than just unfinished. This portrait of a grey heron focuses on its intent expression and the impressive power of its bill, and the elongated feathers on the lower neck and the upper back provide an easy end-point. The long feathers are drawn in full but the shorter feathers below are omitted. There is less of a natural 'stopping point' on the wing so these feathers are just drawn to fade out gradually.

Common nighthawk

The nighthawks and nightjars are close relatives of the swifts and also the hummingbirds. It is difficult to imagine two groups more contrasting in colour than the dazzlingly bright hummingbirds and the cryptically camouflaged nighthawks, but they do have much in common, including long wings that give them great aerial skill, and very small feet that make them rather awkward when they perch. This common nighthawk, a migratory North American species which very occasionally turns up in western Europe too, is shown on a wide perch that supports it in its characteristic almost lying-down posture.

Step 1
Begin this pencil drawing by sketching the main shapes of the bird. The head and body of this species are rather flattened ovals, which overlap slightly as it has a very short neck. The wings and tail are both relatively long, and finish at the same point. Note also the very small bill, and half-closed eye (while not fully nocturnal, this species mainly hunts at dawn and dusk and when encountered in daylight, it is likely to have its eyes closed or partially so).

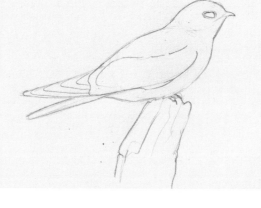

Step 2
Strengthen the key lines and erase the placeholder lines, adding the flight feathers.

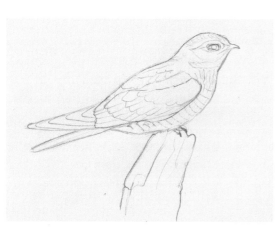

Step 3
Next, add in feather detail on the wing, and start to plot out the markings on the head and body.

Step 4
Begin to add the feather patterns and shade in the eye and bill. Leave spots of white paper for highlights on the eye and nostril.

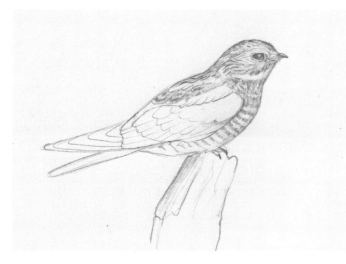

Step 5
Continue to add patterning. Nighthawks have extremely complex feather patterns, which gives them their superb camouflage.

Step 6
As well as adding patterning, it's also time to add shadow, for example under the tail base, and where the feathers of the back overlap those on the 'elbow' of the wing.

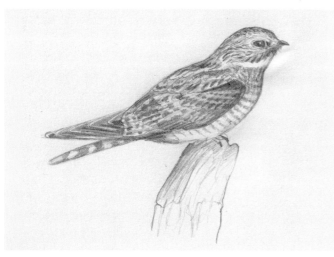

Step 7
Complete the feather patterning, adding the darker marks on the outer wing.

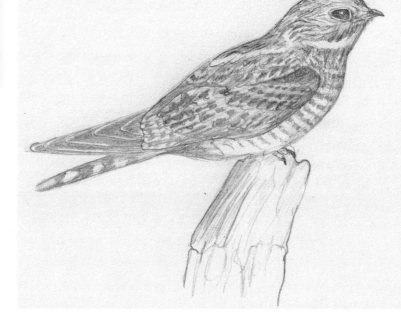

Step 8
Go over the whole drawing once more to intensify areas of shadow and of darker coloration. This will add depth and realism to your image.

Great grey owl

Owls are perhaps the most human-like of birds in their appearance, with their flat faces and forward-pointing, expressive eyes. In truth the owl skull does not look flat at all – the bill projects just as far forward as that of a hawk or eagle. It is the dense feathering of the facial disk that creates the flatness. The entire head of an owl is optimized for hearing, with the disk and its surround of stiff feathers helping to channel sound into the ear openings on the sides of the head. The great grey owl, an inhabitant of quiet open forest in North America and northern Eurasia, is a very big owl if you go by its 70 cm (27½ in) body length, but weighs only about 1.1 kg (2½ lb) – its bulk is all super-soft, lightweight feathering.

Drawing owls is challenging – not only is their plumage intricately patterned, but when portraying them face-on you need to ensure the face and its features are symmetrical. Owls also have their own distinct range of expressions, as well as a general 'look', unique to each species and easily lost if the positions of eyes and bill are not quite right.

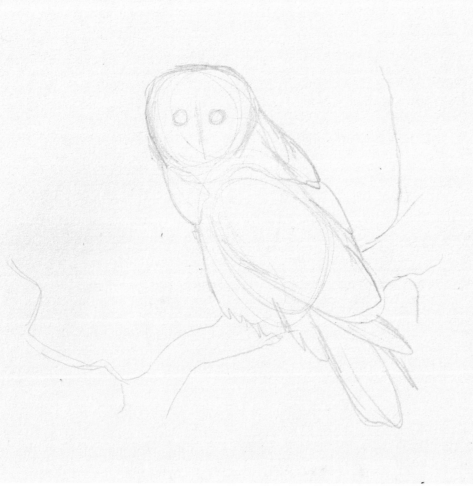

Step 1

It is worth taking time over the preliminary sketch, and making corrections as needed, to make sure the head and body proportions are correct. Pay particular attention to the size and shape of the facial disk (exceptionally big and round in this species) and the placement of the eyes and bill. The body oval is used as a guide but the actual outline accounts for the partly raised feathers on the bird's back and underside.

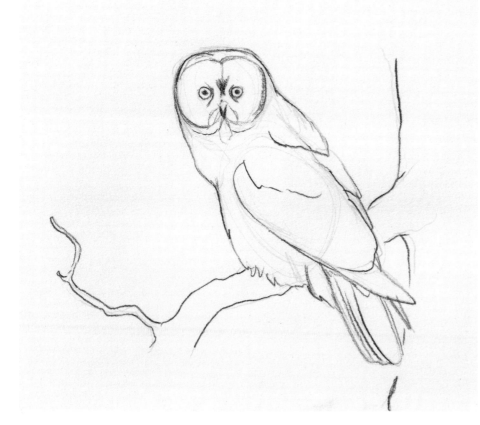

Step 2

Once you are happy with the outline, strengthen your lines and erase some of your guidelines. Adding more detail to the eyes and bill at this early stage helps to ensure that the facial look is right, before you proceed with the long process of adding feather detail.

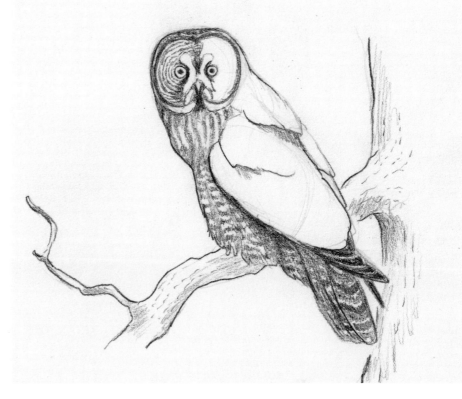

Step 3

Begin to add feather patterning. The contrasting pale and dark areas around the eyes and bill contribute to the owl's distinctive look, as do the fine concentric rings on the facial disk.

Step 4

Complete the patterning of the breast and belly. Note how the underside markings begin as streaks but change to barring further down – this patterning is common in owls. Begin to add tonal contrast to the tree trunk and branch.

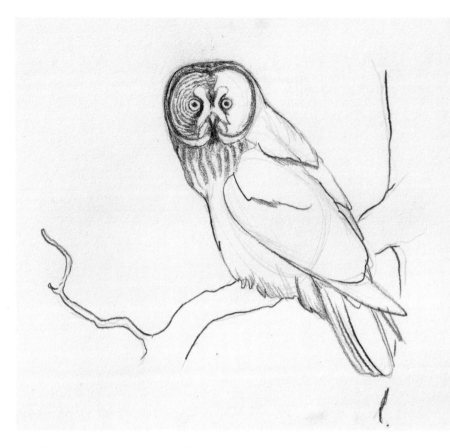

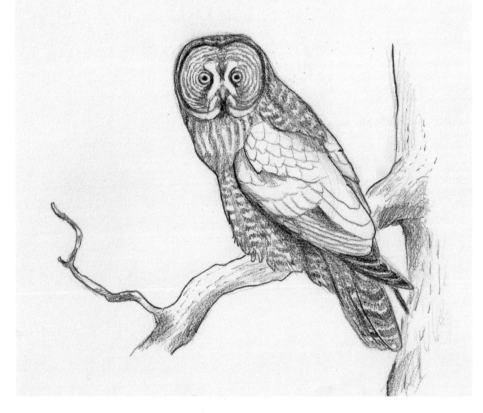

Step 5

Complete the face, maintaining symmetry in the markings, and add barred markings to the back. Add shading to the wing to define the feather tracts more clearly, as well as deepening the shading on the tree trunk and branch.

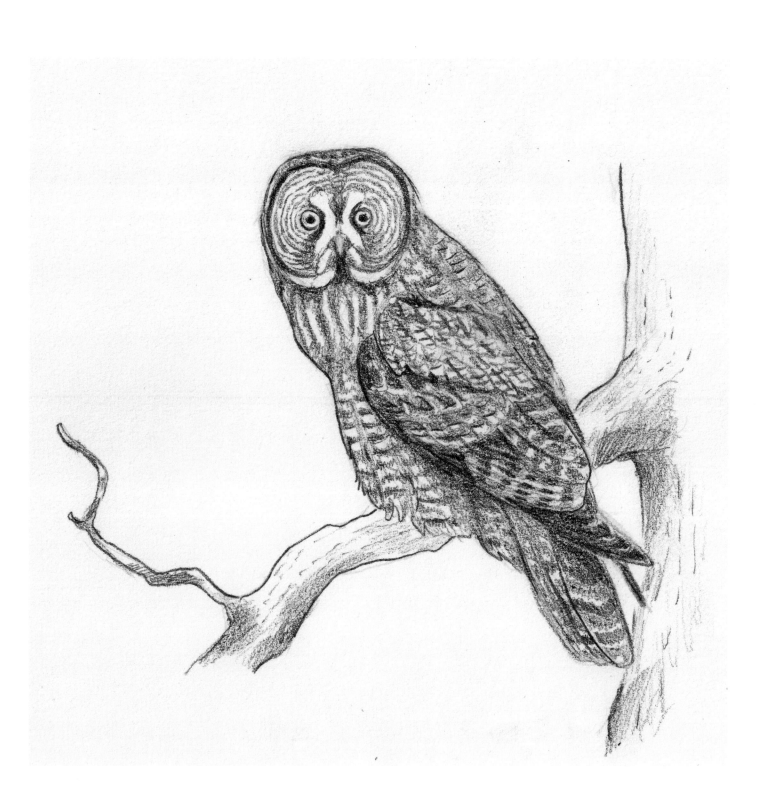

Step 6
Complete the wing by carefully adding the complex patterning to the larger feathers one by one, and build up shading in the shadowed areas to finish the drawing.

Blue tit

The passerines are also sometimes known as 'perching birds'. Most small birds belong to this group, and have feet adapted to wrap around twigs and branches. With such a narrow support, they need to be well-balanced, and the feet are generally under the centre of gravity when they are perched comfortably. Often in a side-on view of a perched passerine, only one of the feet is in clear view. The blue tit, a colourful Eurasian bird that is often seen at garden bird feeders, is notoriously agile and active and readily dangles upside-down, performs the splits and other acrobatics as it moves through the twigs. This picture in coloured pencils shows it in a more sedate moment.

Step 1
To begin, plot out the positions of head, body, the one visible leg, and the twigs on which the bird sits.

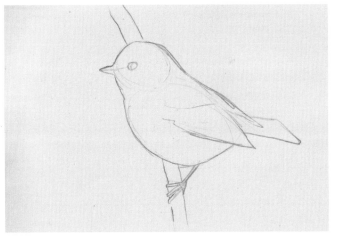

Step 2
Complete the pencil outline by joining up the head and body and adding bill, eye, tail, leg and wing.

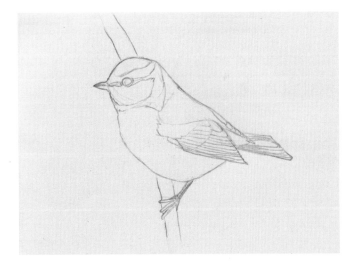

Step 3
Next, add lines to show the feather tracts and different areas of colour.

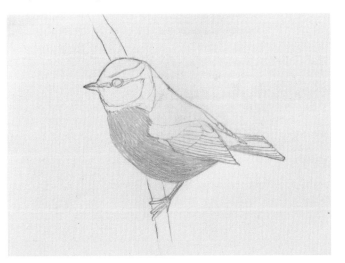

Step 4
Begin to add colour, using long fine strokes of coloured pencil to represent the soft plumage on the bird's belly, and blending yellow with green to shade the underside.

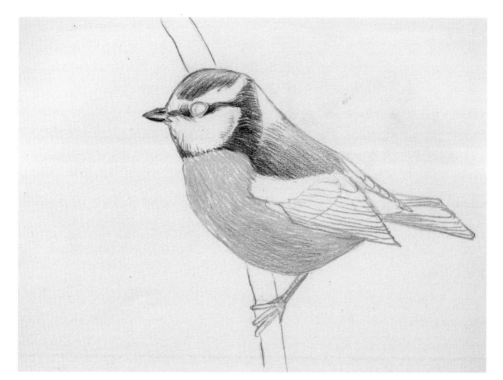

Step 5

Add colour to the head and back. The feathers on these parts are shorter, so make your pencil strokes shorter. Black is blended with blue and olive-green to add shape and shading to the crown and back respectively.

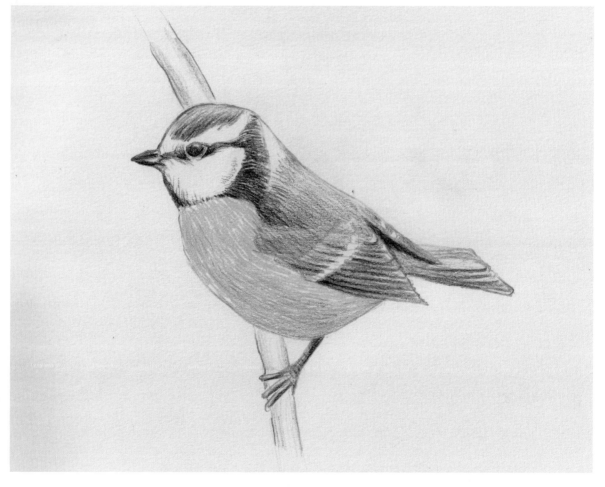

Step 6

Complete the drawing by shading in the wings, tail and leg, and add simple tonal shading to the twig to give it some solidity.

Northern pintail

Many different bird species may be seen swimming on water. They differ considerably in how buoyant they are, and therefore how much of their body is visible – gulls float very high, for example, while cormorants and darters can swim comfortably with almost their entire body submerged. Dabbling ducks such as this northern pintail are relatively buoyant, but they are in fact quite heavy, stocky birds with a generously curved belly hidden under the water. We usually draw our birds at roughly our own eye-level, but if you are using photos for reference, it can be difficult to find images of swimming birds that were taken at eye-level. So this is one area where you may find yourself drawing your bird from a higher perspective – in this case the elevated viewpoint reveals more of the elongated and boldly patterned feathers on the duck's back.

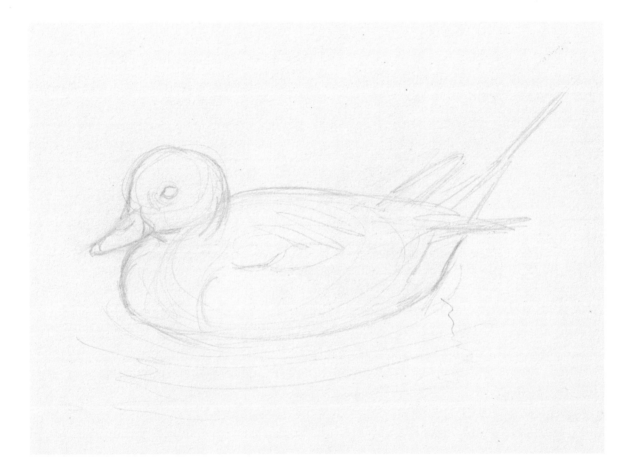

Step 1

Because this pintail is viewed from a slightly raised perspective, the line where its body breaks the water is gently curved rather than straight. Pintails have long necks but this bird is in a hunkered-down pose so it is only the line of its chin that reveals the length of its neck.

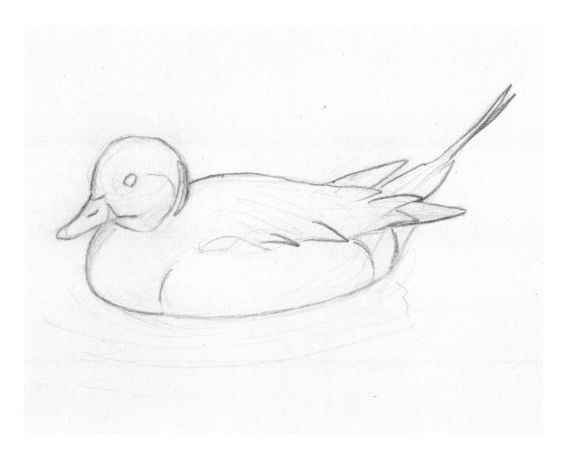

Step 2
After you have completed your outline sketch, draw in the main lines more strongly.

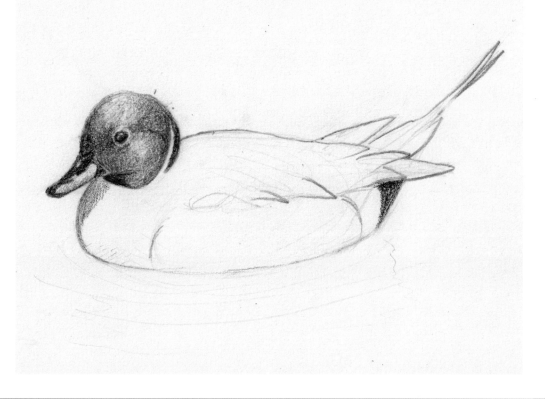

Step 3
Use coloured pencil shading on the bird's head to define its shape, with slightly bulging cheeks, a smoothly domed crown and a deep shadow under the chin.

Step 4

Add colour and detail to the body. The flanks look solid silver-grey at a distance, but close inspection reveals a pattern of very fine vertical dark barring (vermiculation) on a white background.

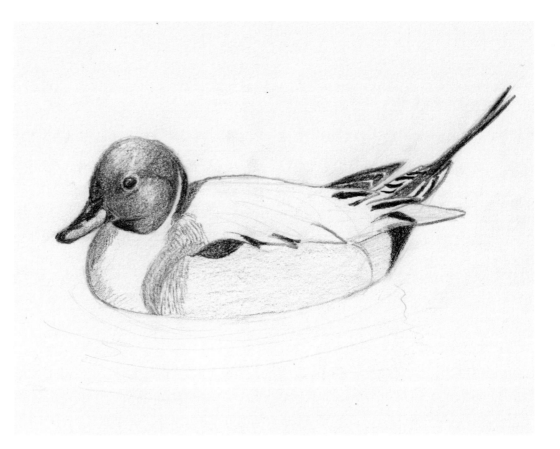

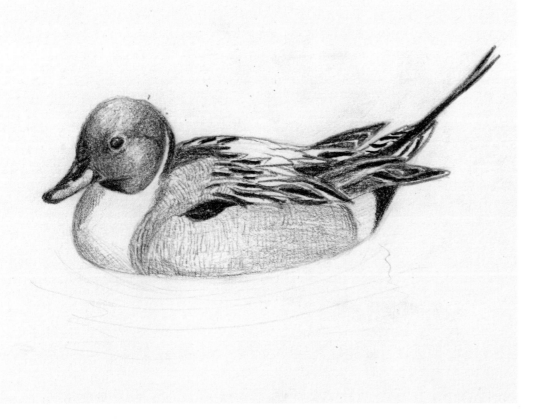

Step 5

Begin to draw in the elongated, dark-centred, white-bordered feathers on the duck's back and overhanging its wings.

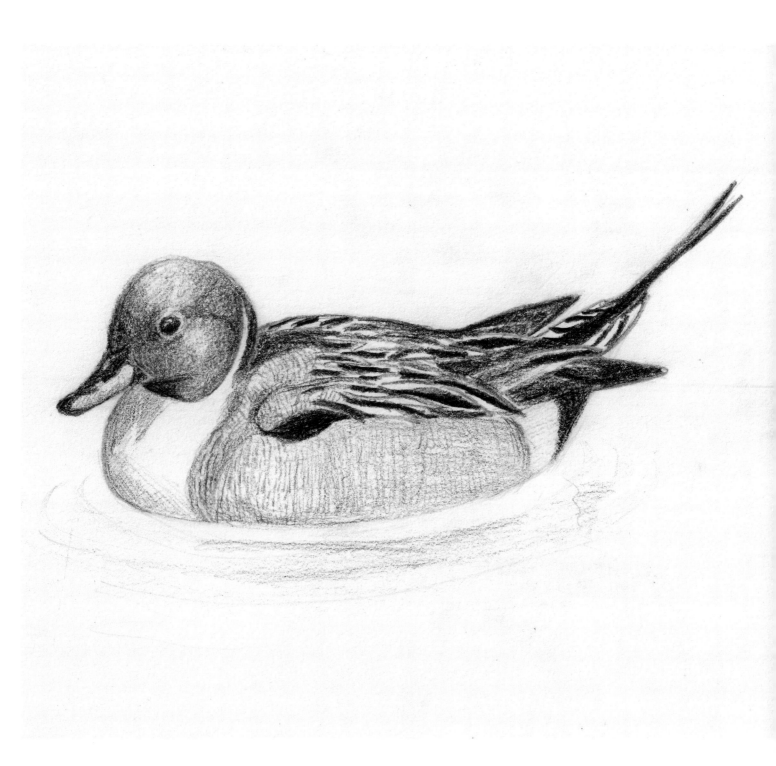

Step 6
Complete the drawing by adding the rest of the back plumage, and a little colour to the ripples in the water.

Laughing gull

Gulls are the most adaptable of seabirds, being very comfortable on land, on water and in the air. They are buoyant swimmers, with the tail and wingtips held well clear of the water, in fact sticking up at a steeper angle than when the bird is standing on dry land. The tail, which is pure white in nearly all gull species in adult plumage, is usually shorter than the wingtips and is often hidden completely between them. Swimming gulls look surprisingly long-necked, especially the smaller 'hooded gulls', and hold their heads on the horizontal plane rather than tilted up as some swimming birds (most notably cormorants) tend to do.

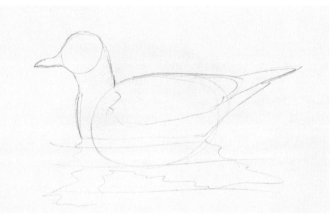

Step 1
This laughing gull is drawn at eye-level, so the waterline intersects its body with a straight horizontal line. In your initial sketch show the full oval of the body, including the submerged part, to get a sense of the bird's overall shape and proportions.

Step 2
Once the outline is complete, strengthen it and add feather detail, as well as an outline for the bird's ripple-broken reflection. Reflections vary greatly according to light conditions and the movement of the water, but when the bird is on the water (as opposed to standing close by it) the reflection is likely to be at least somewhat broken because, even if the water is very still, the bird itself is probably moving a little.

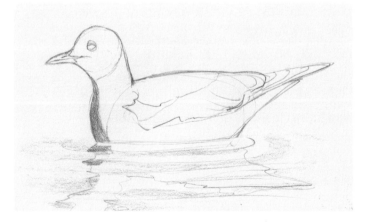

Step 3
Add some colour and shading to the gull and to the water. To achieve the effect of ripples on the water, alternate white and blue lines in concentric ovals around the gull's body.

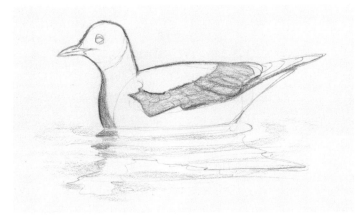

Step 4

To make this a bold and graphic image, strengthen the bird's outline using a black pencil. Add colour to the wing.

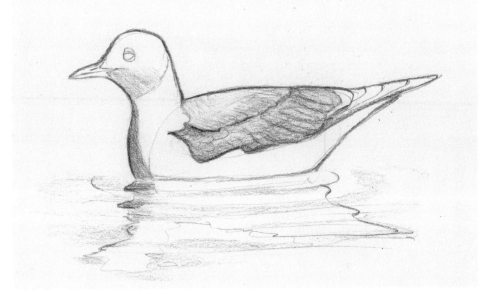

Step 5

Shade in the rest of the upper side and begin to shade the head and define the reflection.

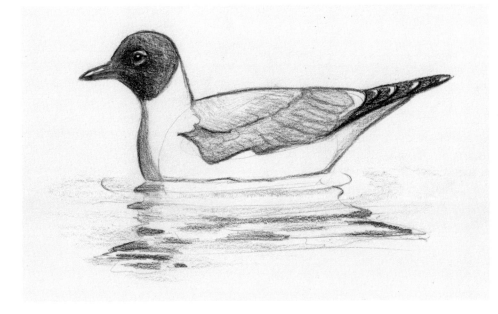

Step 6

Complete the drawing by shading the head in full, including the distinctive red-rimmed eye and bill. Colour in the wingtips, shade the underside beneath the wingtips and complete the reflection using loosely shaped areas of tone.

Greater flameback

There are more than 200 species of woodpecker in the world. They live wherever trees grow, and some species have adapted to thrive in more open habitats as well. You are more likely to see one clinging to a vertical trunk or branch than perched in a more conventional way – they hang on with their strong claws, but also use their stiff tails as a third support. The greater flameback is a spectacular large woodpecker native to southern and south-eastern Asia. As with many woodpecker species the male (as shown here) is a little more colourful than the female, sporting a vivid red crest while the female's is blackish. Gouache paint is a good choice for bringing out these vivid colours.

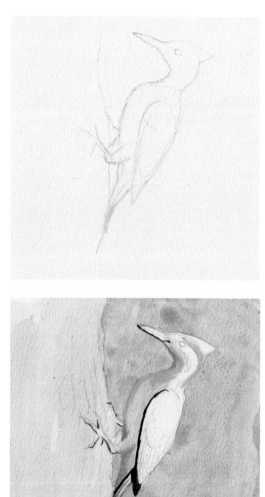

Step 1

In your initial sketch, work on getting the bird's proportions and posture right. It is angled at about 45 degrees from its vertical perch.

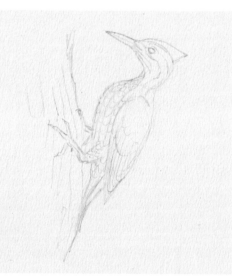

Step 2

Add more detail in pencil before beginning to paint. Dark fringes to the feathers on the underside give a scaly appearance, with the scale shapes becoming larger as we move down the body, reflecting the increasing size of the feathers. Note the feet with their two-forward, two-back toe arrangement, and that the toes are well spread out, to provide as secure a grip as possible.

Step 3

Add a swirly green backdrop to suggest deep woodland surroundings. Give the tree a light brown wash to begin with, and then start colouring the bird itself as shown. Use a fine-pointed brush to create the black lines on the undersides of the wings, bill and feet.

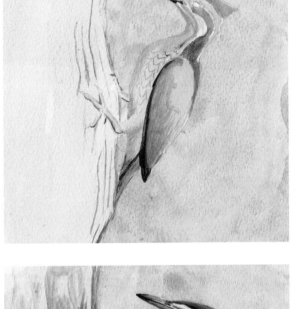

Step 4

Add a bright golden-green wash to the back and wings, and finer detail to the darker areas on the bird and the tree bark.

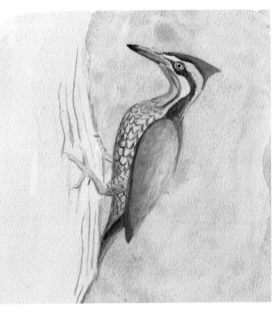

Step 5

Continue to build feather detail. The head bears a complex striped pattern, but you will stay on track if you remember that the markings follow the feather tracts which we explored in Chapter 1 (see page 38).

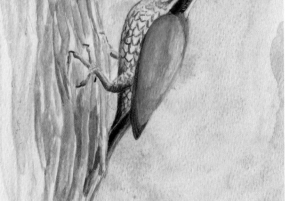

Step 6

Build darker tones to add shape and solidity to the body, and extend the detail on the tree bark using bold strokes of your brush.

Step 7

To complete the painting, add more intense tones to the colourful parts of the bird's plumage and stronger dark tones to the areas in shadow – the underside of the tail, legs, lower belly and chin.

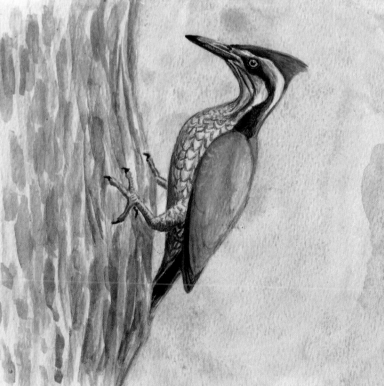

Rough-legged hawk

Birds of prey usually perch in an upright posture, even when resting. This has the effect of disguising the length of their legs, as most of the leg is hidden in the feathers. When they are standing over prey with their body in a more horizontal posture, the leg length becomes apparent, though many species have generous feathery 'trousers' that cover the leg above the ankle bend. The rough-legged hawk, an Arctic species found in North America and Eurasia, has feathered lower legs too, with only its toes bare and exposed to the elements. Befitting its chilly habitat, it has thick plumage and often looks rather rotund, fluffy and cuddly for a bird of prey – it is also able to keep its toes warm by sitting upright and fluffing out its belly feathers.

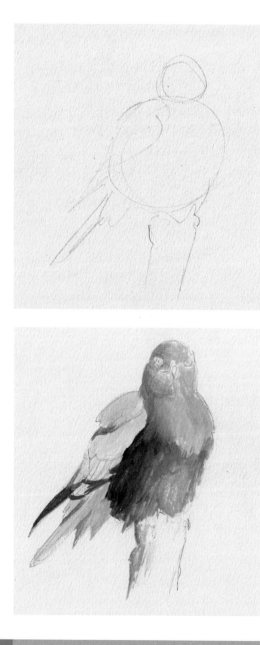

Step 1

In this preliminary sketch, showing the bird almost front-on and in a fluffed-up posture, the ovals of head and body are actually circles, and just overlap. The taloned toes are just peeping out from under the belly feathers.

Step 2

Add feather and face detail in pencil. Raptors' bills are relatively short and strongly down-curved, and this distinctive shape makes them a little easier to draw head-on than most other birds. A long, straight bill shown head-on with complete foreshortening looks peculiar in photographs and is extremely difficult to show well in a drawing!

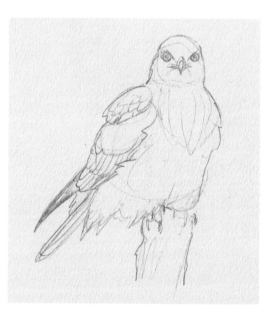

Step 3

Use gouache paint in strong shades of brown and golden-cream to give the bird its basic colour scheme and to add shading that indicates light coming from the right-hand side. In this painting there is no coloured background and the bird stands alone on the white paper, perhaps suggesting a wintry environment.

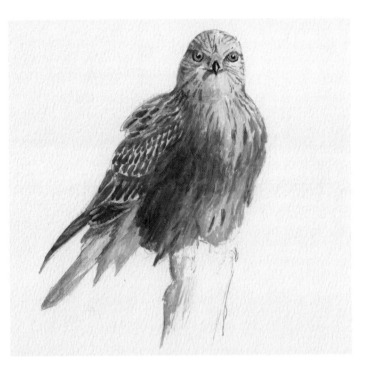

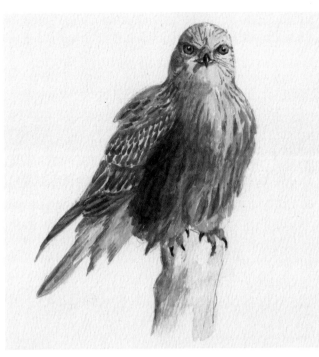

Step 4
Paint the detail of the wing feather tracts, and begin to work on the face. When plumage is held loosely like this, painting individual feathers becomes more important.

Step 5
Add a strong ochre colour to the toes that roughly matches the colour of the nose above the bill, and dark hook-shaped talons. Add more detail and shading to the face and body, and begin to work on the perch.

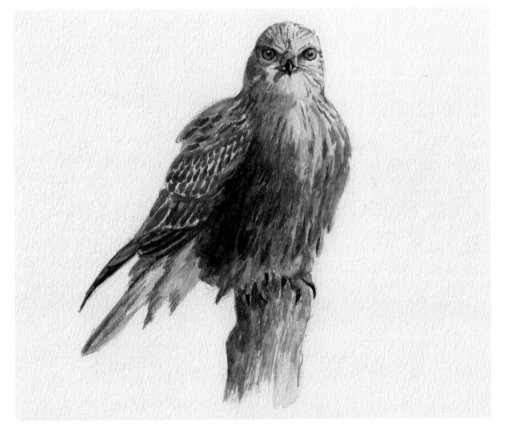

Step 6
Complete the toes (including white highlights on the shiny talons) and add soft detail to the wood of the perch.

Black-faced cormorant

The black-faced cormorant of Australia is a typical example of its family. It swims very strongly on and under the water, using its large, fully webbed feet (all four toes are connected with webbing), and its lack of buoyancy allows it to swim well at shallow depths, rather than having to dive deep to reach neutral buoyancy like some other seabirds. However, it is rather ungainly on land and stands quite upright as its feet are positioned close to its rear end. Like many seabirds it has bold black-and-white coloration, which serves as camouflage (black plumage is hard to make out against the dark sea when looking down, while white plumage is less conspicuous when viewed against the bright sky from below).

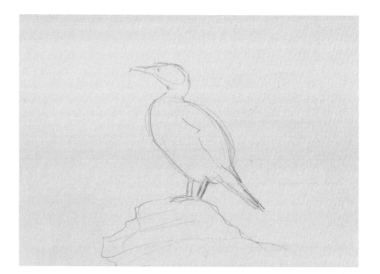

Step 1
Begin by making an outline sketch of the bird perched on a rock, looking much bulkier on land than it does in the water.

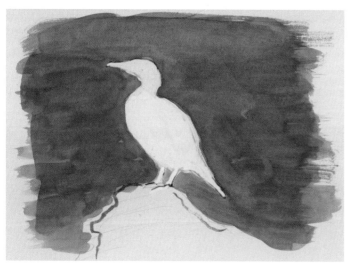

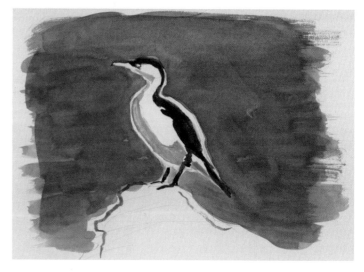

Step 2
Fill the background with a deep indigo wash to suggest a backdrop of deep sea.

Step 3
Begin to paint the bird. A bold and loose style is used here, to complement the very strong but simple range of colours and tones in use.

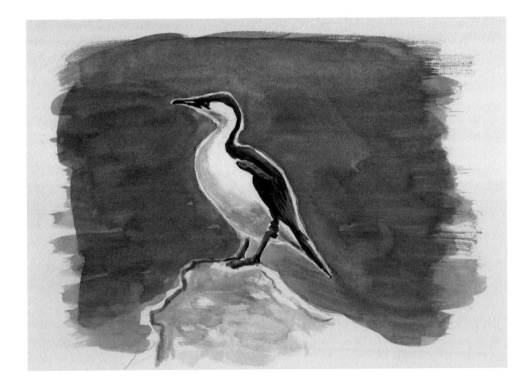

Step 4
Add more detail and shading, while maintaining a narrow white halo around the bird to help it stand out against the dark background.

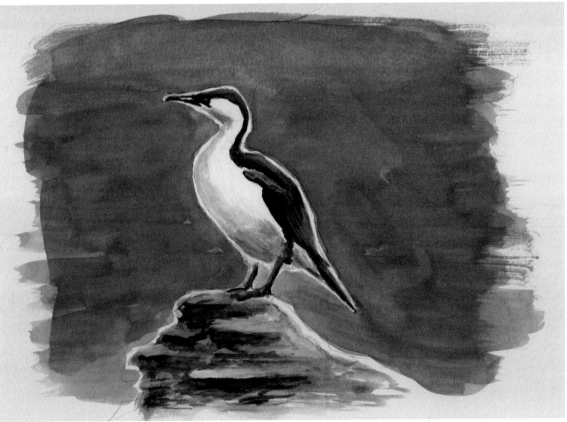

Step 5
Add detail to the rock using horizontal brushstrokes to emphasize its layered structure. To finish the image, deepen the shading slightly on the white parts of the bird.

Sandhill crane

Large birds with long necks and legs, such as the sandhill crane, can look very elegant as they stand or walk slowly, scanning the ground for insects, small mammals and other possible prey. When drawing and painting these birds, pay careful attention to the relative sizes of head and body, the S-shaped curve of the neck, and the position of the legs. Birds with this general shape include storks and herons, spoonbills and bustards, as well as the cranes, of which the sandhill is a widespread species in North America. Cranes are especially elegant for such large birds, and most species prefer to hunt in wetland or grassland areas – they will often gather in large flocks outside of the breeding season.

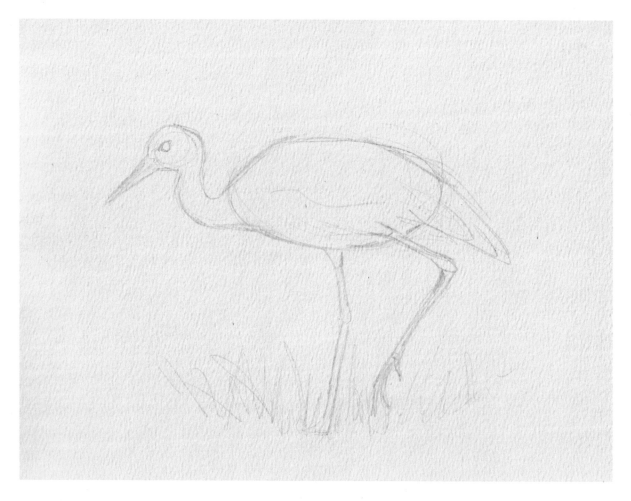

Step 1
Make an initial sketch of the crane's outline, noting that the head is very small relative to the body. When the bird is walking it holds its head down (almost level with the body) and tilted towards the ground. Its neck is in a gentle curve. It is rare that you will see birds like this holding their neck straight, except in flight (though herons fly with their necks tucked in) and when making a strike at prey. When walking, the legs will rarely bend more than 90 degrees as they lift off the ground.

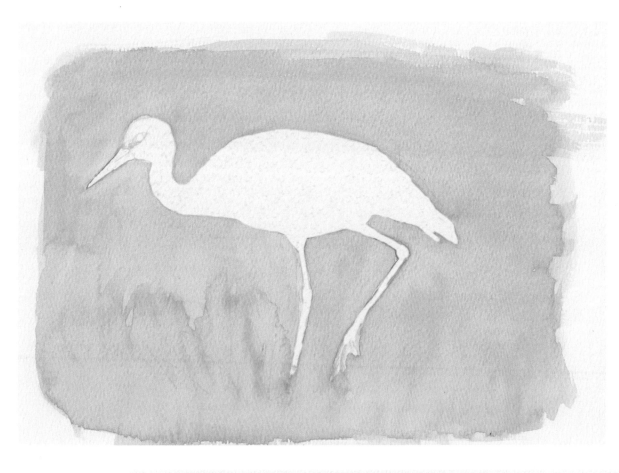

Step 2
Erase the pencil outlines, and add a loose golden-brown wash of gouache to the background.

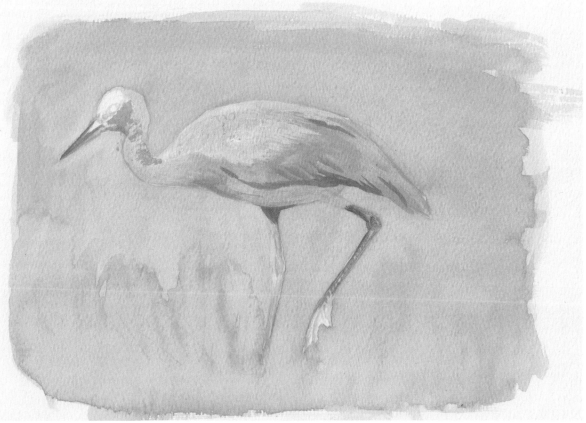

Step 3
Start to paint in the plumage of the crane, in shades of grey gouache with hints of brown.

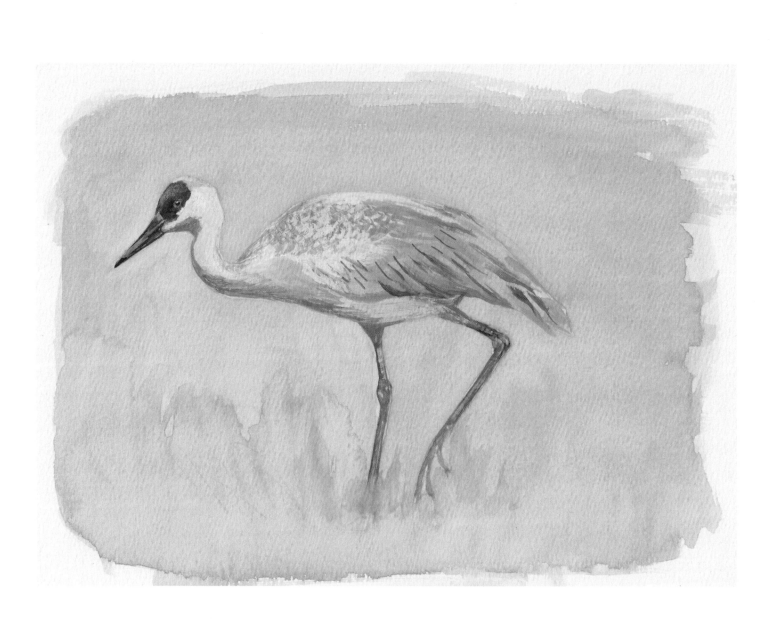

Step 4
Build up the detail, adding the colourful head marking and eye.

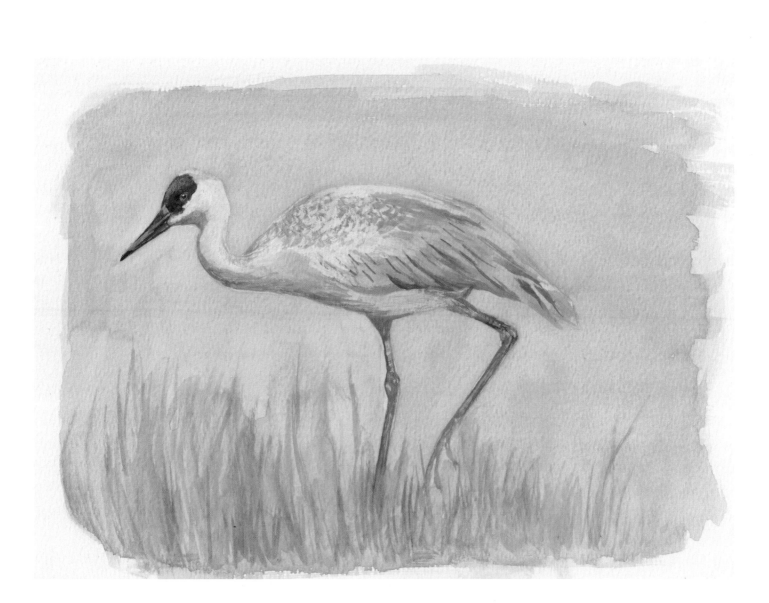

Step 5

Complete the painting by adding grass detail in the foreground. The grasses conceal the crane's standing foot, so imagine where the foot would be on the page were it visible, and make sure that the grass is painted down to at least that point.

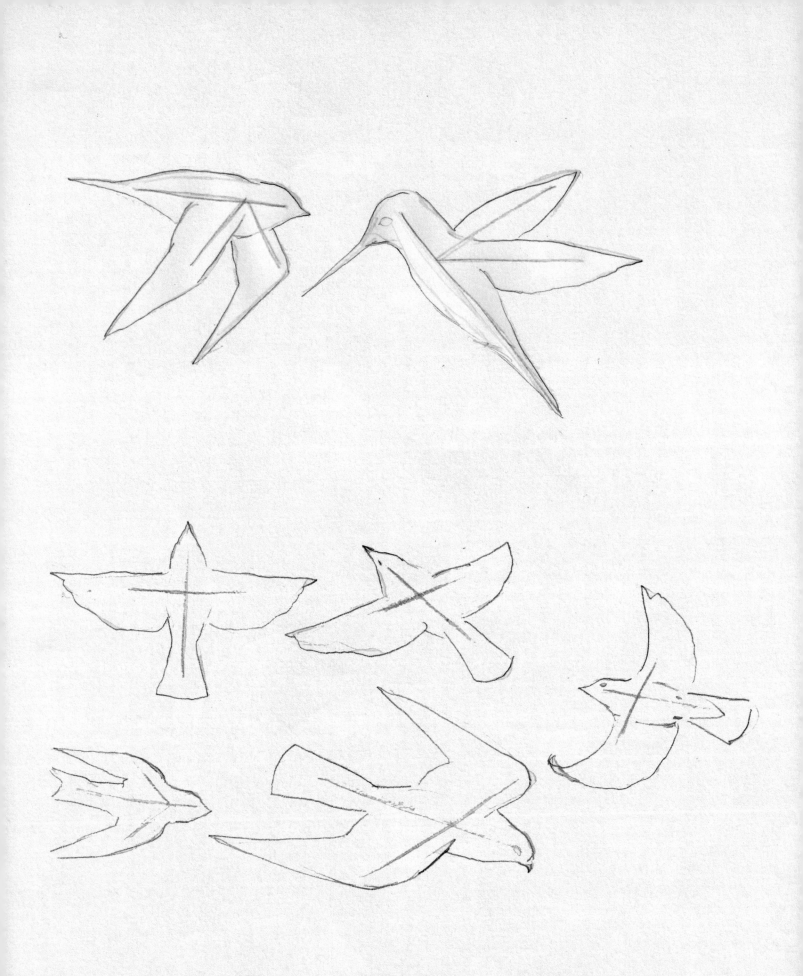

Birds in Flight

Nearly all birds can fly, and they all have a similar wing anatomy, in terms of feather types and arrangement as well as the lightweight arrangement of muscles and bones beneath. However, their flight styles vary enormously. Compare the languid soaring of an eagle to the high-speed blur of a hovering hummingbird, or the direct, powerful flapping of a duck to the wheeling and flickering of a swift or a swallow. A look at the wing shape can give you a clue as to how a bird flies. Short and broad wings give agile but energetically costly flapping flight; broad-based wings with pointed tips provide more speed; and long and broad wings are optimized for flap-free soaring.

Drawing birds in flight is undoubtedly tricky. Making the two wings mirror images of each other is difficult enough, but if the bird is angled so that one wing is closer to you than the other, you have to contend with perspective and foreshortening as well, making the far wing smaller so that it appears to be further away. Paying close attention to the width of the wing where it connects to the body will help you to get this right. In most flight poses, the rest of the bird is usually held in a straight, horizontal line, but not always. Note that flying birds nearly always keep their heads level even when they are turning so sharply that their bodies are in an almost vertical position.

Depending on the style of your piece, you may or may not want to show the individual wing feathers on your flying bird, but the underlying structure of the wing is key. Think of each wing as a continuous structure which can straighten or fold around a central joint, like an arm, rather than a collection of feathers. (Remember though, that the joint in a bird's wing is its wrist, not elbow, so it bends the opposite way to an arm!) As usual, we start with exercises in pencil, before progressing to coloured materials and some slightly more complex compositions.

Cross shapes

When visualizing a bird in flight, think of the wings as forming a continuous straight line at right angles to the body, so the bird as a whole forms a cross shape. This is a good starting point for your drawing, and works especially well if the bird is flying with its wings fully outstretched and held horizontally. Wings do move, though! They flex at the wrist bend, and they also beat up and down and can be pushed forwards or drawn backwards. In these positions, you will need to adapt your central lines. Remember too that the wings attach to the body at the same points on both sides, as these sketches of birds in various flight positions show.

American robin

We rarely get a good look at small passerine birds, such as this juvenile American robin, in flight. They are fast with rapid wingbeats and their flights are often quite brief – from one branch to another. They are not prone to soar or glide for any length of time, and when they do cover long distances in the air, during their migrations, they tend to travel at night. Photo references are therefore very helpful to show the different wing positions. A side-on view like the one shown here is easier than most other options, as you draw the head and body much as you would for a perched pose (just positioned on a more horizontal plane) and it's only necessary to draw one wing in full. Small birds fly with their legs tucked into their belly feathers and only their feet visible (sometimes even the feet are covered by feathers).

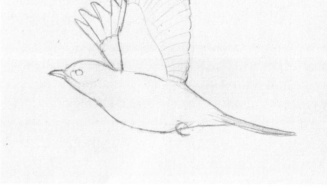

Step 1
Begin with the usual double oval, but on a more horizontal plane – imagine the bird is lying down on its belly rather than perched. The wing that we can see in full starts at the base of the neck and its width extends to the rump. Its overall shape is quite rectangular when fully spread.

Step 2
Rub out the rough sketch lines and go over the outline with a stronger, darker pencil. Add the eye and the wing feather tracts.

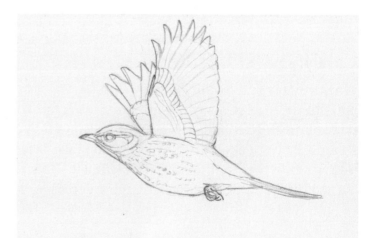

Step 3
Begin to draw in the patterning. Unlike the adult with its dark brown and brick-red plumage, the juvenile American robin has a more detailed pattern, with spots on its belly that follow the feather tract lines.

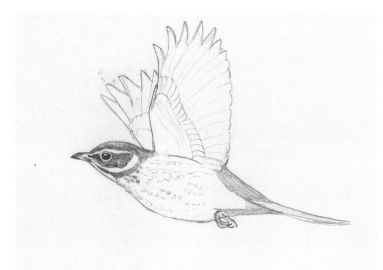

Step 4
Add in strong shading on the head and rump. Pay careful attention to the detail of the face pattern, with pale stripes above the eye and encircling the cheek – there is also a distinct pale ring around the dark eye.

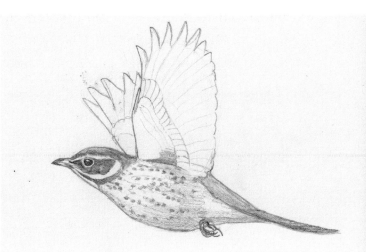

Step 5
Lightly shade in the underside, creating the spotty pattern with patches of darker tone. Also add shadows on the lower belly and under the tail. Add shading to the curled-up foot.

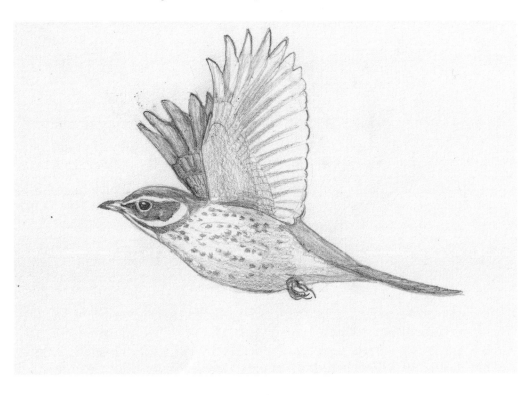

Step 6
Complete the shading on the wings. The upperside of the wing is dark, while the underside is paler.

Pied harrier

Birds of prey are admired for their skill in the air, but different groups have different flying styles, and different wing anatomy to match. Falcons have long, broad-based and sharply pointed wings, giving great speed in the air. The goshawk and its relatives have short, broad wings for manoeuvrability in dense forest. The largest birds of prey, such as vultures and eagles, have long and wide wings, ideal for lengthy spells of soaring on thermals, while they search for food. Harriers have long, rather narrow but broad-tipped wings, proportionately very big for their bodies. Their wing shape and body proportions enable them to use energetic flapping flight for long periods, as they patrol open grassland in search of small prey below. This pied harrier is in typical hunting flight, with wings beating, legs dangling and head tilted downwards, looking and listening for movement.

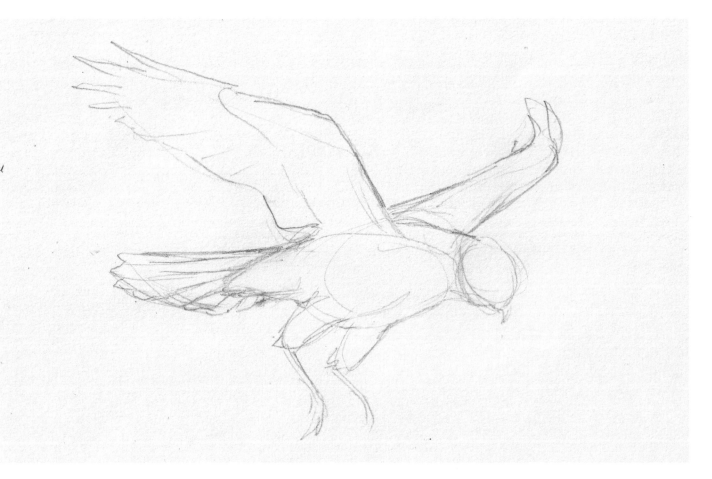

Step 1
Make a careful initial sketch, as the shapes are quite complex. The bird is turned a little towards us so we are looking across its shoulders to a far wing that appears much smaller than the near one. This perspective also has a dramatic effect on the shape of the spread tail.

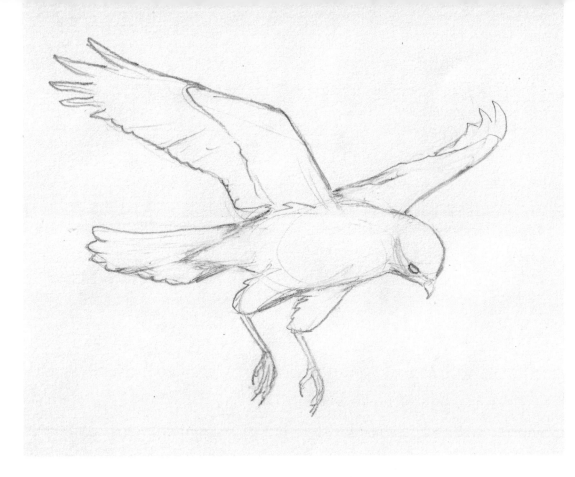

Step 2
Once the initial faint sketch is about right, add stronger holding lines to the outline, eye, and some feather groups.

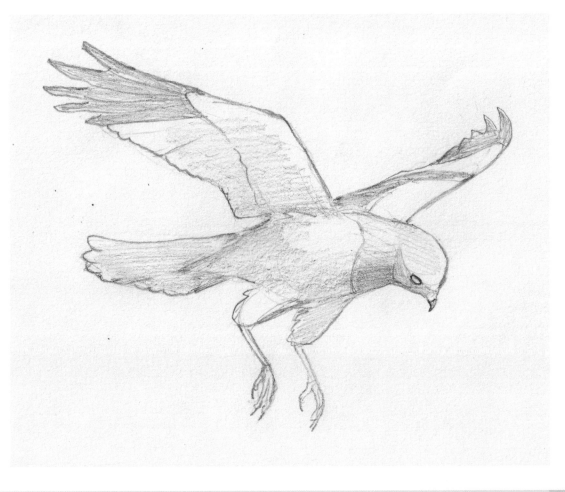

Step 3
Begin to add shading, showing the bird's crisp black-and-grey pattern with dark head and upper breast, wingtips and wing band.

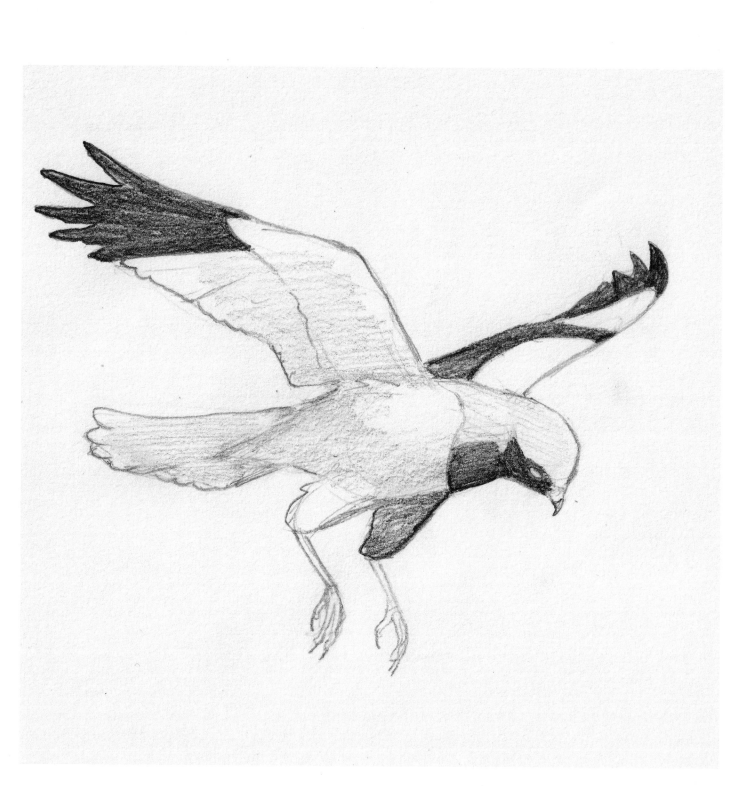

Step 4

Switch to a softer, darker pencil to shade the very darkest areas more deeply. Although the plumage on the top of the head is black, leave it lightly shaded to indicate where the light falls.

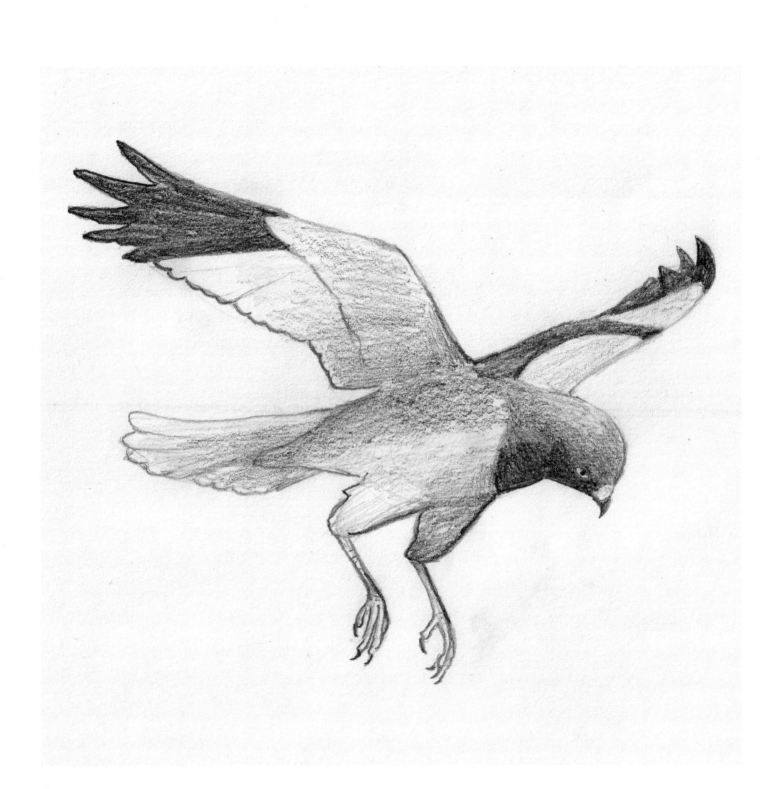

Step 5

Continuing with a soft pencil, blend in the shading on the head and body.
The shadowed areas show less contrast between pale and dark plumage
than we see on the well-lit upper side of the far wing.

King eiders

Here we see a line of three flying ducks, in a similar formation to the classic decoration sometimes seen on the walls of an English country house or more humble abode. This drawing shakes up the formula a little, by using three king eiders (an Arctic species of sea duck) rather than the usual mallards, and by having the birds in slightly differing positions. In reality, when birds are flying together in a flock their wingbeats will often be closely synchronized, and photographs usually show their wings in a similar position. Ducks, especially eiders, fly very fast and use a lot of energy in flight, as they are heavy-bodied with proportionately small wings. The legs are held stretched backwards and pressed against the tail, to minimize the drag that could be produced by those large webbed feet. However, you will also see ducks and geese using their feet as highly effective air brakes when they need to slow down and lose height quickly.

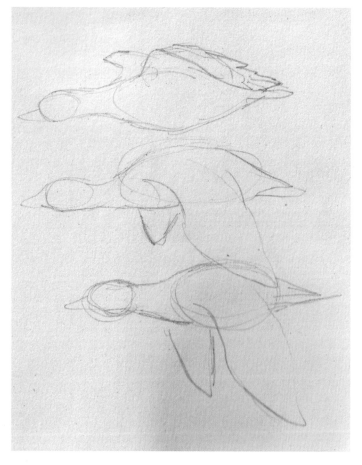

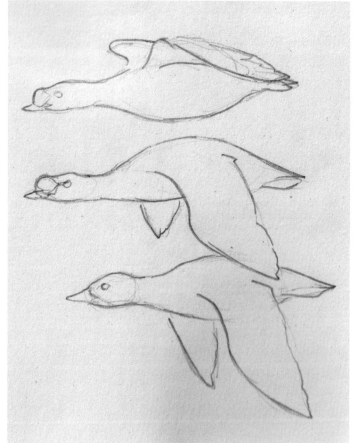

Step 1
Draw the three outlines, focusing on body shape and wing positions. Ducks in flight look small-headed with long (and, in the case of this species, rather thick) necks.

Step 2
Solidify the outlines, and add the large bill-base swellings on the two male birds (top and centre).

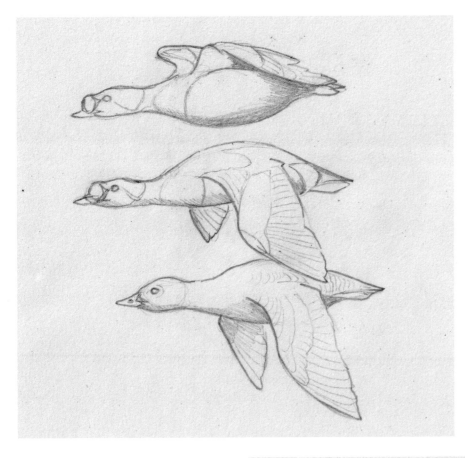

Step 3

Add detail to the bills and faces, marking out areas of plumage colour contrast on the two male birds, and shading in the parts of the wings and bodies that are in shadow.

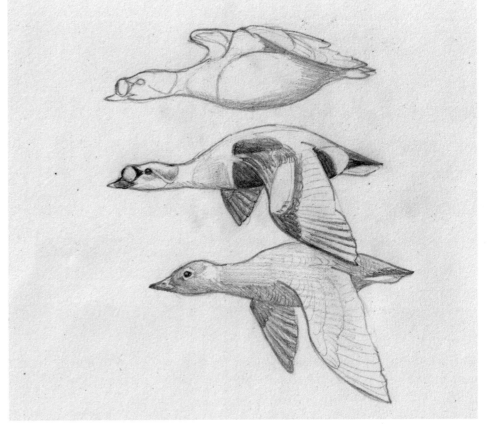

Step 4

Start to fill in plumage detail on the centre male and bottom female bird.

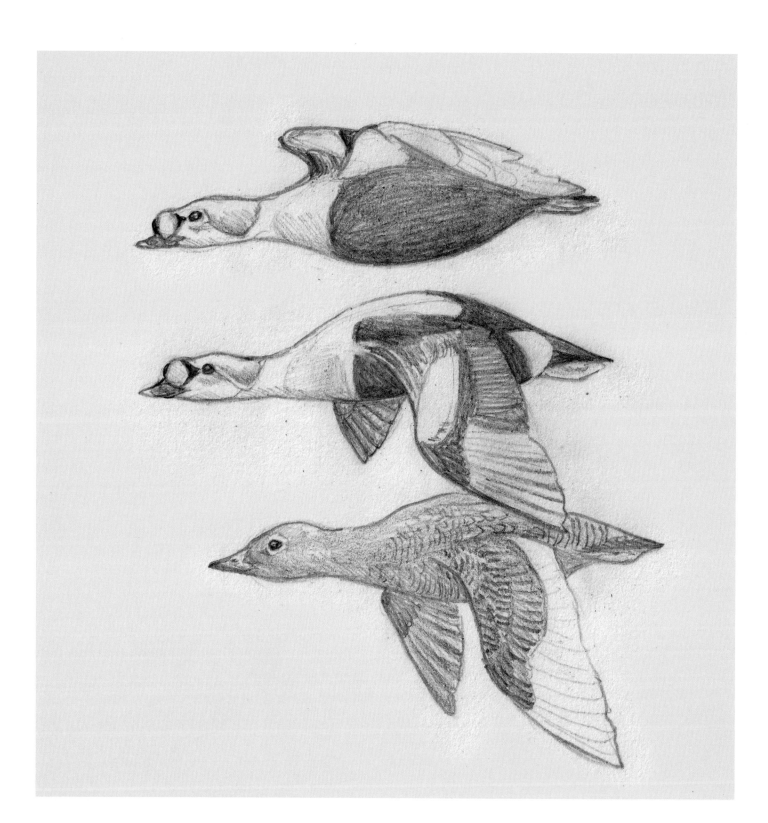

Step 5

Add the areas of contrasting plumage to the top male bird, and continue working on the feather detail of the female. She is more evenly shaded but displays more intricate feather patterning than the males.

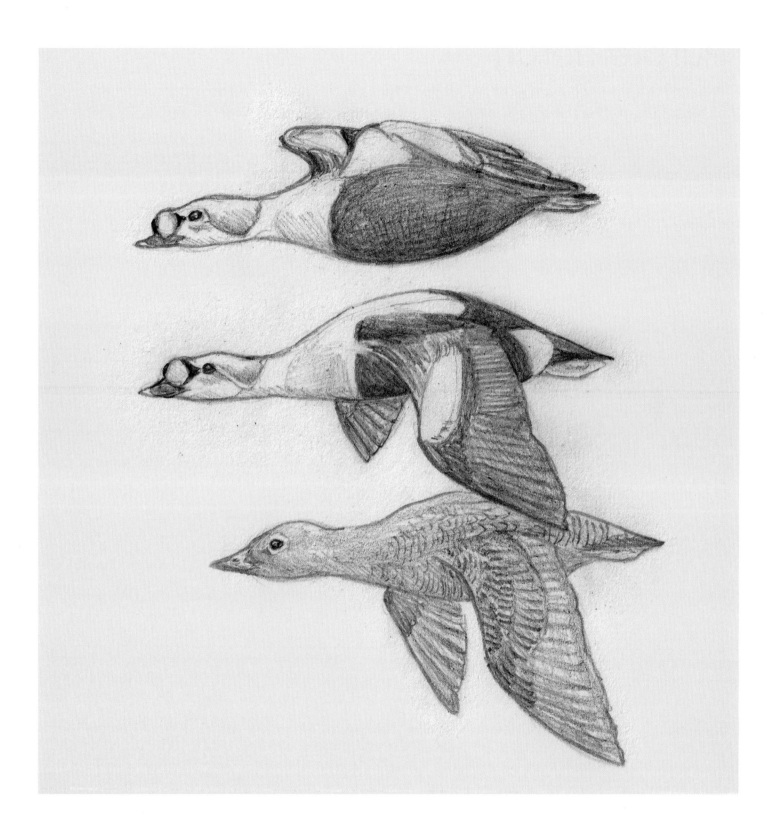

Step 6

Finish shading all the flight feathers to complete your drawing.

Purple heron

Large birds like this purple heron, native to Eurasia, are often slow and graceful in flight. Most long-necked birds fly with their necks outstretched but the herons fold theirs so that the head is tucked against the body with the tightly S-curved neck forming a bulge underneath. In longer-legged birds the legs are almost invariably held stretched out, as this is the most aerodynamic position for them given their great length, and the toes are also stretched out behind, well beyond the tip of the tail. This heron, drawn in coloured pencil, is shown angled towards the viewer, so quite a lot of the back wing is visible.

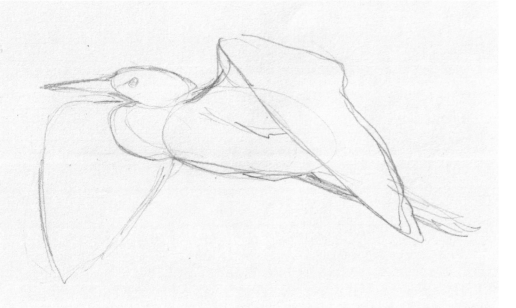

Step 1

Make your initial sketch. It makes life easier to choose a viewpoint where the bird's bill does not overlap the far wing. The wings make quite unusual shapes so observe these carefully as you draw.

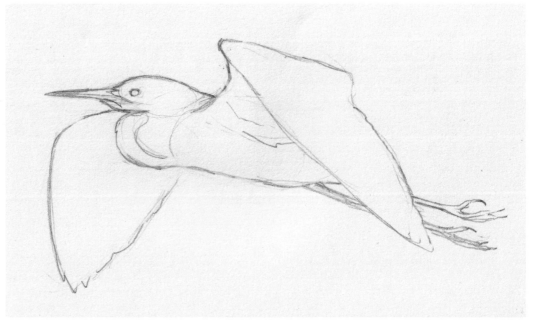

Step 2

Complete the outline by solidifying the correct lines and erasing placement and error lines.

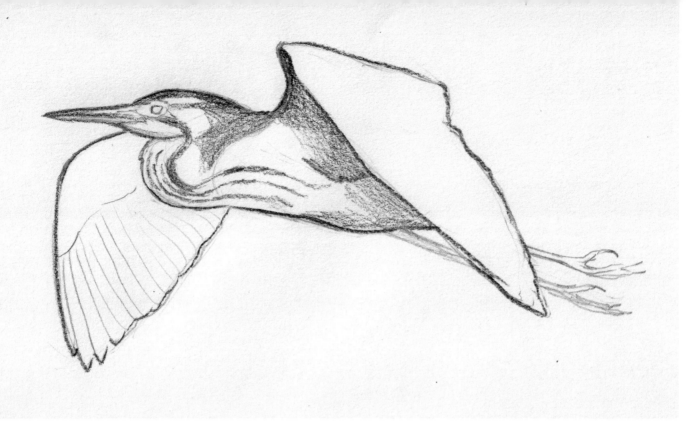

Step 3
Use coloured pencils to begin adding tone and shadow to the bird's body, and to accentuate the outline.

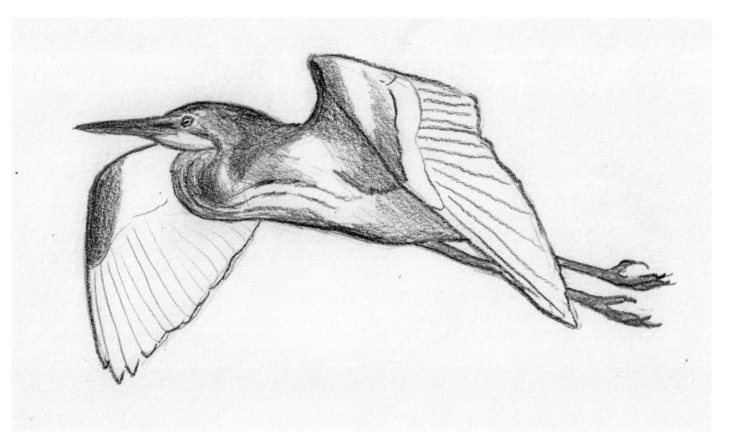

Step 4
Continue to build up colour, adding yellow tones to the bill, eye, legs and feet.

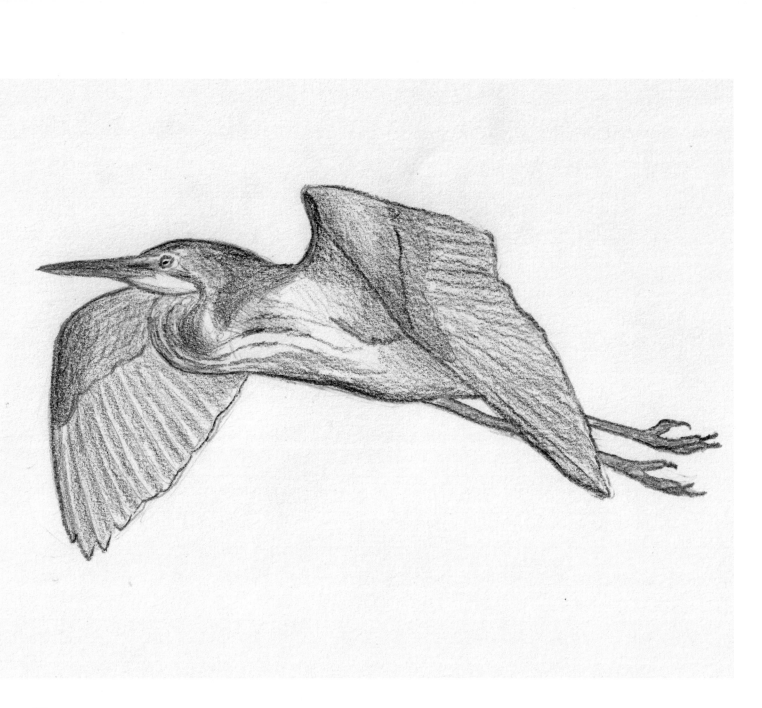

Step 5

Shade the wings, using a combination of blue and black pencils and marks that follow the direction of the feathers.

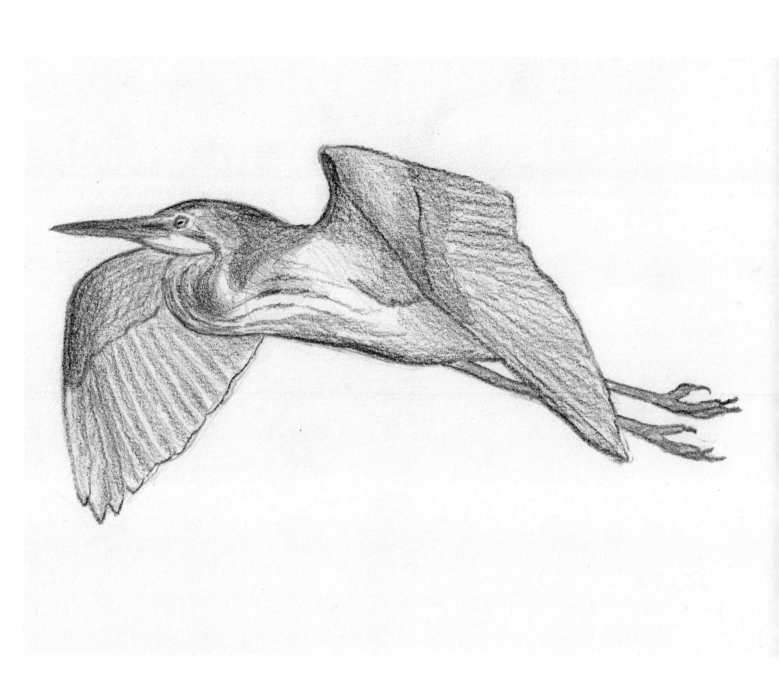

Step 6

If you spot an error, don't hesitate to make a last-moment correction by erasing and redrawing. Here, the flight feathers on the far wing were drawn with the outermost feather overlapped by its neighbour when it should have been the other way round!

Violet-green swallow

Swallows, such as the violet-green swallow of North America, are among those passerines that spend a lot of time on the wing, as this is where they hunt their prey. Their flight is fast but includes some glides with the wings held out still. This bird is shown almost side-on with both wings fully open and in view. When drawing and painting a bird in this pose, be sure to line up the points where the two wings meet the body, at both the leading edge and the trailing edge of the wing. Note also that a bird's tail shape changes depending on whether it is fanned out or closed up. The violet-green swallow's tail looks slightly forked when it is closed, but when it is fanned out, as shown here, it has a squarer shape as the tips of the longer outer feathers line up with the shorter inner feathers.

Step 1

A detailed initial sketch shows the usual head and body ovals, which overlap in this short-necked species, and plots out the shape of wings and tail. The bird is slightly below our viewpoint, so the nearest wing appears larger and broader at the tip than the far wing. The near wing has the outermost flight feathers flicked up at the tip.

Step 2

Once the proportions are right, complete your outline drawing by adding feather detail and positioning the eye.

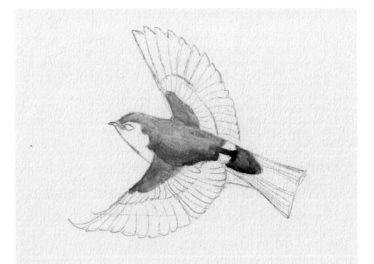

Step 3

Use gouache to fill in the areas of vivid iridescent green on the bird's head, back and bases of the wings, with shading to give a subtly rounded shape to the back. The upper tail coverts are painted blue, with a narrow blue line through the centre of the white rump.

Step 4

Begin to work on the flight feathers on the near wing and tail. These feathers lack iridescence and appear blackish-grey. Also add some shadow to the underside of the white body, and some violet tones to the upper tail coverts.

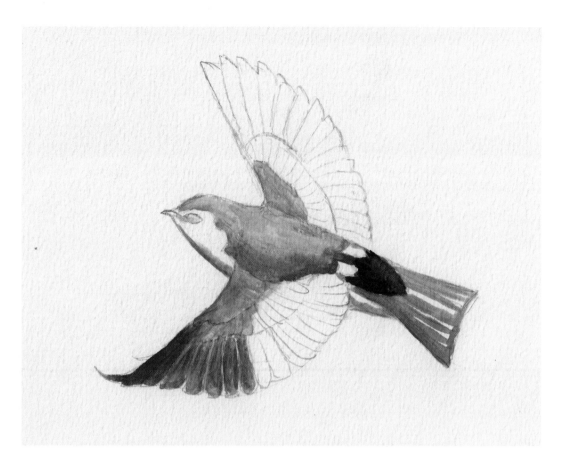

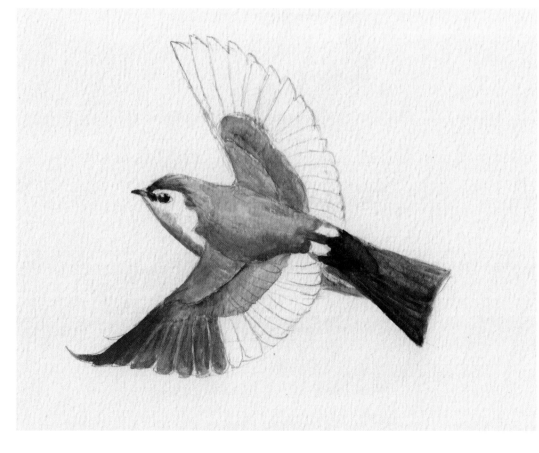

Step 5

Add more detail to the darker wing and tail feathers. To achieve a sense of depth and texture, paint in the darker parts of the feathers and then wash over with a slightly lighter grey before the first, darker areas have completely dried. Add a blue wash to the larger wing coverts which reflect a subtle blue-violet iridescence. Work on the face, adding a dark eye and bill.

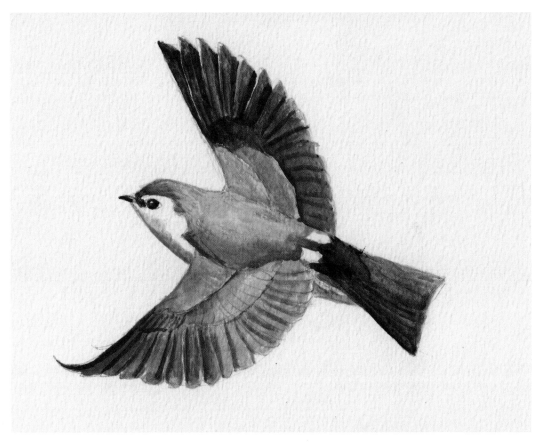

Step 6
Complete the flight
feathers of the far wing.

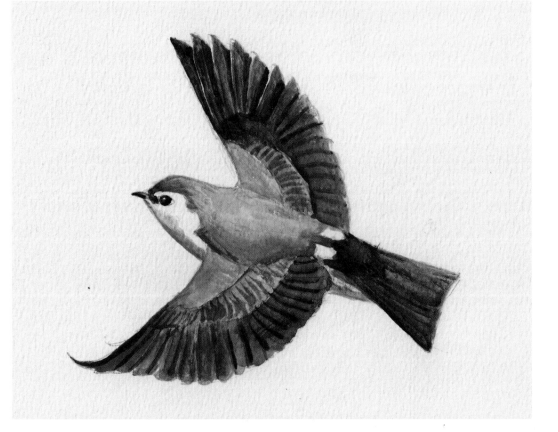

Step 7
Finish the near wing's flight
feathers, adding shade and
detail to the larger wing
coverts.

Black-browed albatross

Albatrosses are supremely adapted to energy-efficient flight at sea. They use a technique called dynamic soaring, where they ride rising air currents that form between wave crests. Albatross wings are extremely long and narrow – they have more secondary flight feathers than any other bird, with the larger species having up to 40. These unusual wing proportions are key to drawing this bird in flight. Here it is shown in a gliding and turning posture with the body tilted so the wings form a near-vertical line, almost making a cross. However, note that the head is turned during this manoeuvre so that it remains parallel to the ground (or the sea in this case). Birds in flight show remarkably stable head positioning even as their bodies tip and tilt at various angles. They tend only to move the head from the horizontal plane when they spot something in their close vicinity, such as another bird approaching them.

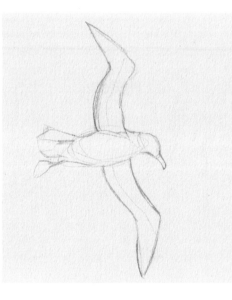

Step 1

Sketch the albatross with flattened ovals for head and body, and make sure that the wings are placed opposite each other on the body. These birds have very narrow wings, which means that the trailing edges meet the body higher up than is typical. Note also how long the wing 'arm' is (the section before the wrist bend) – about twice the length of the 'hand'.

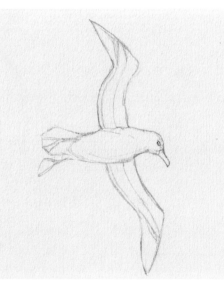

Step 2

Complete the outline sketch and add the eye and some feather detail.

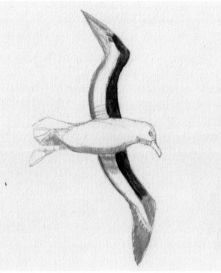

Step 3

Begin to paint the dark areas of the wings – a broad dark band on the leading edge and a very narrow one on the trailing edge. The wingtips are also dark. Using a light wash, shade in the underside of the body, and the base of the downward-pointing wing where the bird's body casts a shadow.

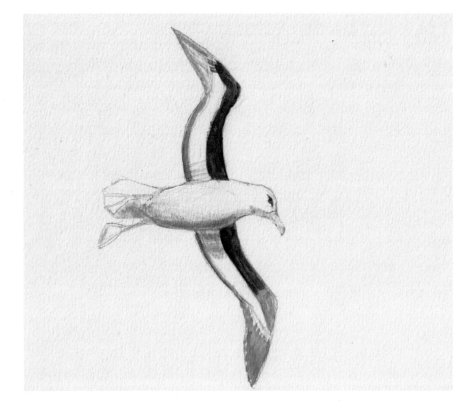

Step 4

Begin to refine the shading and, using a fine-tipped brush, paint in the eye with its dark brow above.

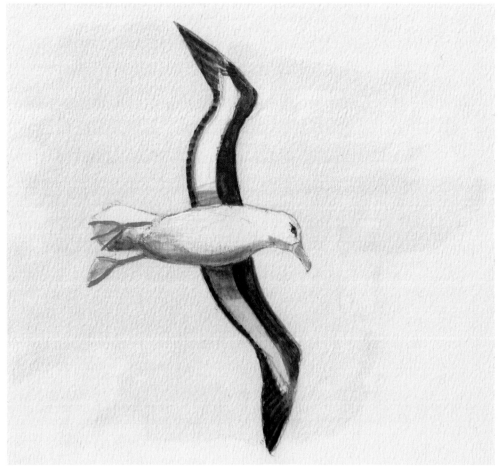

Step 5

Add a light blue background wash and fill in more of the dark areas on the wings. Paint in the bill and feet in a pale grey-pink.

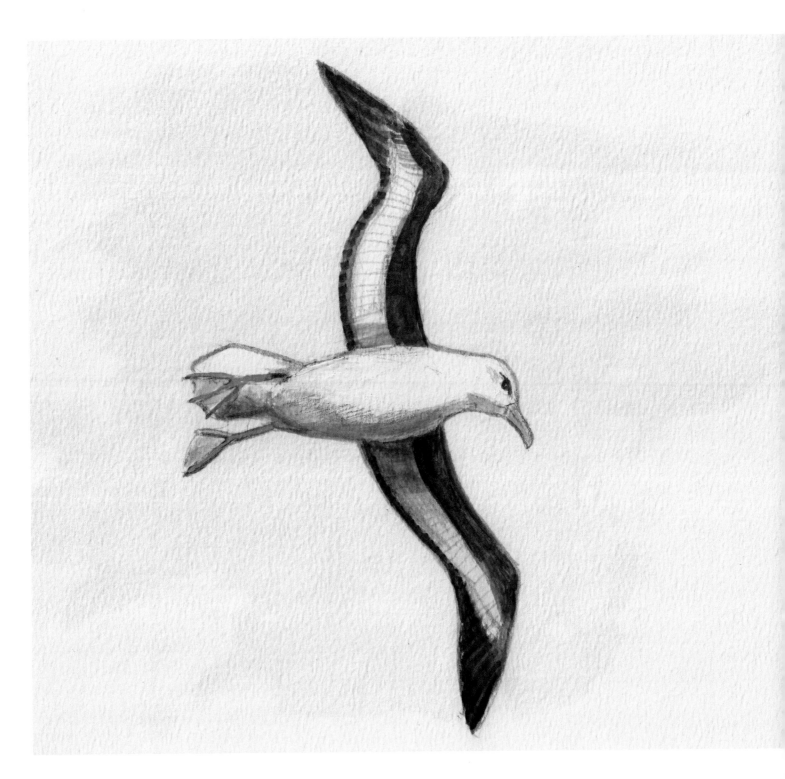

Step 6
Complete the painting with a stronger holding line for the outline, fine lines to indicate the white wing-feathers, and intensified shading.

Red-billed streamertail

Hummingbirds are exquisite, with their tiny size and dazzling iridescent colours. However, they are also full of fire and fight, which inspired this somewhat combative pose for a gouache painting of a male red-billed streamertail, the national bird of Jamaica. These birds have relatively long but narrow and pointed wings, which beat extremely fast but are also very flexible, allowing them to hover on the spot or make rapid turns. When hovering, they hold their bodies relatively upright. The male streamertail's greatly elongated central tail feathers are also highly flexible and whip about dramatically as the bird dashes and darts from place to place, creating an eye-catching display.

Step 1

This hummingbird is sketched almost head-on to the observer, but turning slightly away, meaning that the nearer wing appears larger. In your initial sketch, try to capture the flexibility of the flight feathers and the tail streamers.

Step 2

Draw in the outlines of the bird more strongly, ready to begin painting.

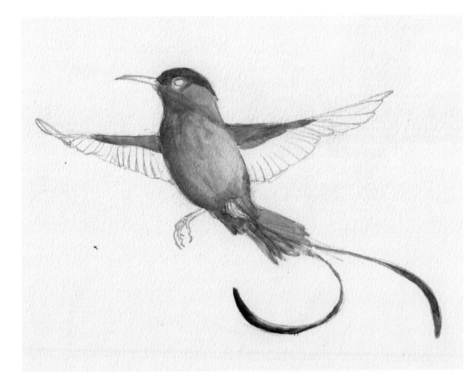

Step 3
The streamertail's iridescent plumage appears green, but this is best created by using bright yellow on the best-lit parts of the body, as darker scaly markings will be added later. The darker parts are washed in with blue initially.

Step 4
Add the black crown, leaving a lighter line along the top to show where the light falls. Complete the red bill and dark, pale-circled eye and begin to work on the wings.

Step 5

Continue working on the wings and add shading to the body and underside of the tail.

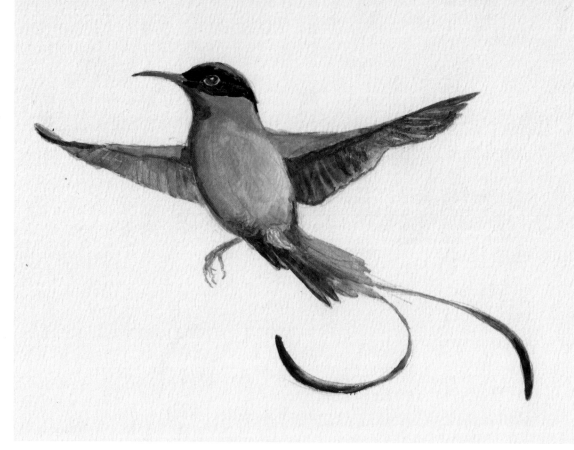

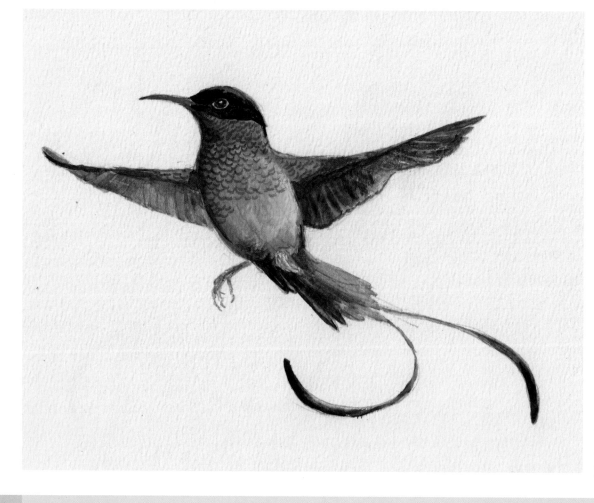

Step 6

Use a very fine brush to add the feather patterning to the underside, as a series of semi-circles that just touch each other.

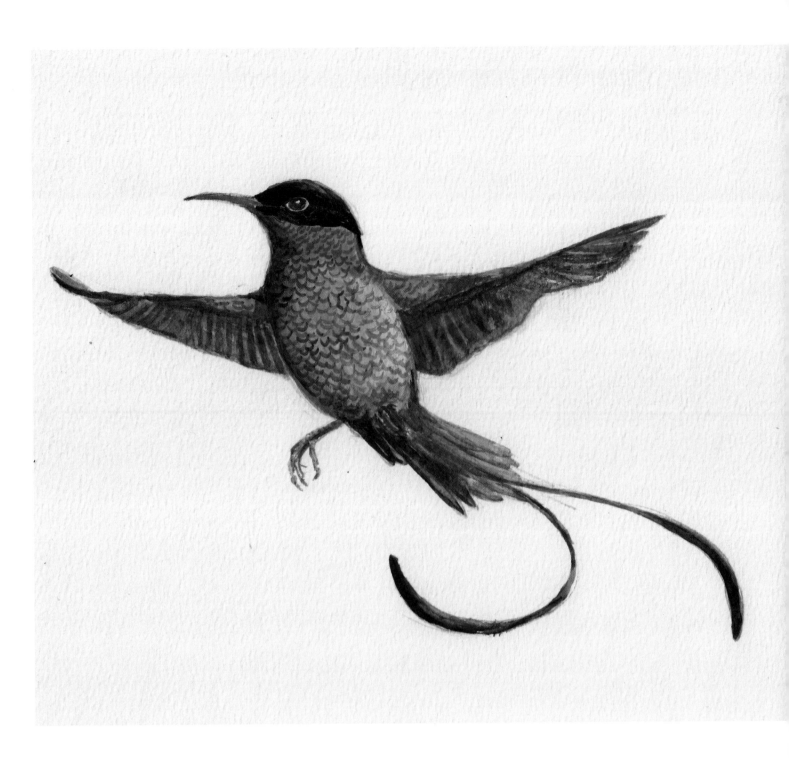

Step 7
Complete the feather patterning and finish off detail in the other parts of the bird, such as the definition on the feet.

Northern gannets

Plunge-diving is one of the most dramatic forms of flight. Diving onto prey from a height, the bird tips itself head first and lets gravity take over – but it retains control all the way down. Northern gannets are skilled divers and have various adaptations to protect their bodies from the impact of hitting the sea surface at as much as 96 kmph (60 mph), including nostrils that open inside the bill, and large air sacs under their skin to cushion their necks. They begin the dive with their long wings open but then pull them in before impact, turning their bodies into a streamlined javelin shape to punch deep underwater, where they (hopefully) capture a fish before swimming back to the surface. The shapes these birds form in the air as they dive are dramatic and striking, and to be surrounded by large numbers of them in a feeding frenzy is an unforgettable experience.

Step 1
The two poses shown here were drawn from photographs of the same individual, taken moments apart as it began to dive. The drawing is intentionally kept quite loose, with the 'pointiness' of the birds accentuated.

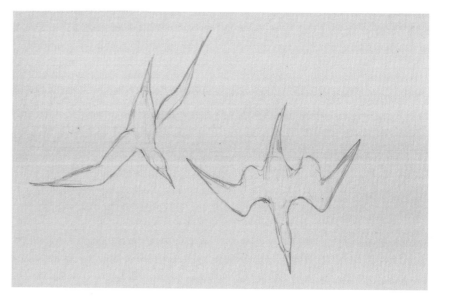

Step 2
Once you are happy with the overall shapes, clean up and solidify the two outlines.

Step 3

Add a loose wash of blue-green to represent the sea. You could use masking fluid here to keep the birds' shapes white, but in this example they will be painted back in with white gouache paint.

Step 4

Once your background wash is dry, add white highlights to the brightest parts of the birds.

Step 5

Paint in the black wingtips and yellow napes, and add grey tones to the shadowed parts of the bodies.

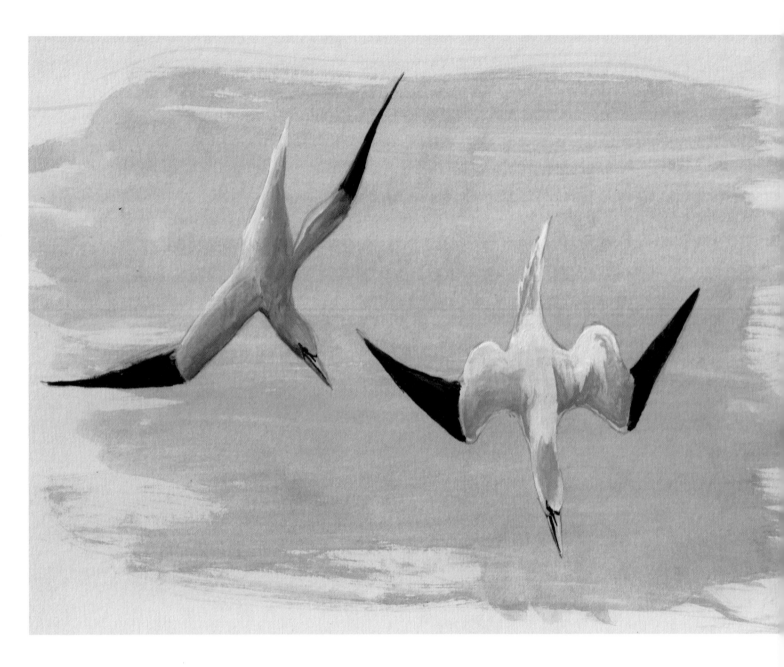

Step 6

To finish the painting, intensify the grey tones on the shadowed parts, blending them carefully with the white without sacrificing the strong contrast between lit and unlit plumage. A very fine brush is needed to add a little detail to the birds' faces.

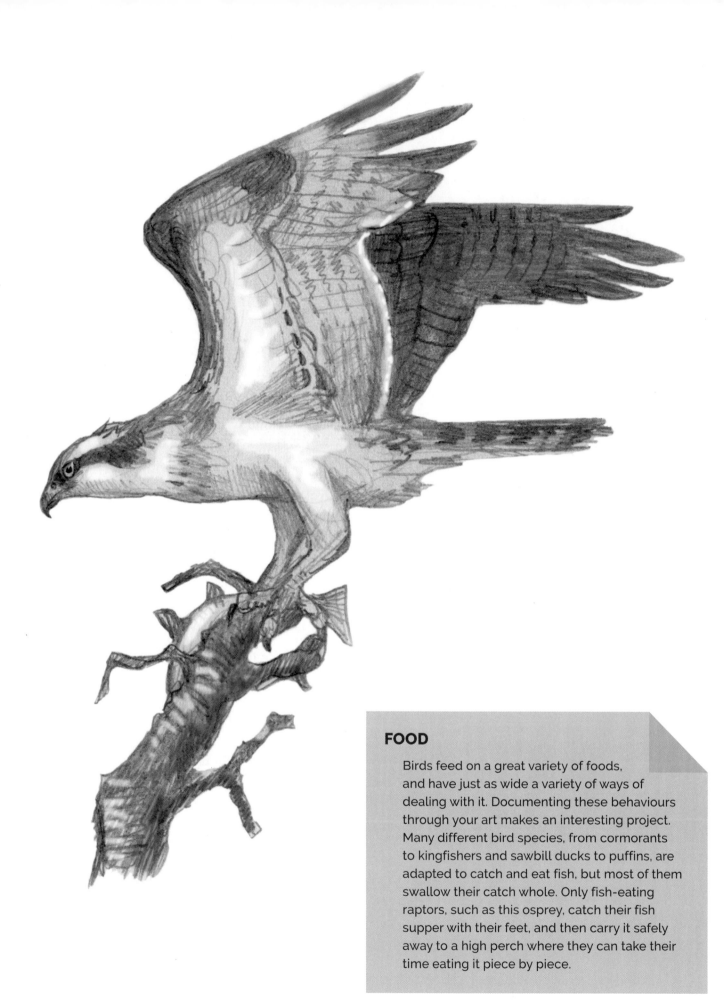

FOOD

Birds feed on a great variety of foods, and have just as wide a variety of ways of dealing with it. Documenting these behaviours through your art makes an interesting project. Many different bird species, from cormorants to kingfishers and sawbill ducks to puffins, are adapted to catch and eat fish, but most of them swallow their catch whole. Only fish-eating raptors, such as this osprey, catch their fish supper with their feet, and then carry it safely away to a high perch where they can take their time eating it piece by piece.

Bird Behaviours

Birds lead busy lives, and if you watch one for any length of time you will see a wide range of behaviours. Depending on the species, these may include preening, handling food, diving underwater, climbing, running, jumping, bathing, sleeping and singing. Add other birds into the picture and the range of behaviours increases to include interactions such as courtship, care of chicks, and fighting. Drawing and painting birds engaged in these activities can be even more of a challenge than capturing them in flight, but the results are often full of spark and vigour.

You may have established a preference for working with certain materials and you can use whichever you like to complete the exercises. However, you will find that birds with particularly vivid plumage or bills are most suited to rendering in colour. When it comes to portraying groups of birds, you may wish to start with studies in pencil so as to focus on the dynamic between individuals. We shall start with exercises in pencil, before progressing to the eye-catching colours of the rainbow lorikeet (see page 115) and the unforgettable display of the Indian peacock (see page 118).

Sketching from life is useful no matter what type of drawings and paintings you wish to do, but if your particular interest is showing birds in action, then you will find it particularly helpful to spend time watching and sketching living birds. You can do this with the wild birds that visit your garden, or spend time at a zoo or wildlife park, or settle down in one of the birdwatching hides in your local nature reserve – anywhere that birds congregate and can be watched at reasonably close range will provide you with ample material. The final pages of this chapter offer some hints and tips on getting the most out of this challenging but highly rewarding activity.

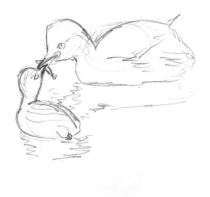

Family life

For most birds, the process of finding a mate, making a nest, incubating eggs and raising chicks takes up a large part of the year. These activities provide the artist with some charming material. Both male and female little grebes are devoted parents and you may see them carefully feeding small fish and other prey to their tiny fluffy chicks. Birds' courtship dances are also fascinating subjects for the artist, often involving remarkable posturing and showing off exaggerated plumage features. However, birds that are actually at their nests are less popular as subject matter these days, and for good reason. Nesting birds are extremely sensitive and vulnerable to disturbance, and it's best to avoid doing anything that might identify their location or encourage people to get too close.

Masai ostrich

Ostriches and their close relatives (rheas, emus and cassowaries) are very different to other birds. For a start, they are gigantic and heavy, and flight was jettisoned long ago in their evolutionary history. Their size makes them safe from many predators, and their running speed (especially impressive in ostriches and rheas) gives them another layer of protection. The Masai ostrich is adapted for walking and running efficiently. Its long, powerful legs end in broad, two-toed feet, with both toes facing forward to allow a smooth and rapid gait. Its shaggy, fur-like plumage is sparse on the lower body, meaning that the knee joint is sometimes visible as well as the ankle joint. When running at full speed on those long but sturdy, prominently muscled legs, it calls to mind a human sprinter.

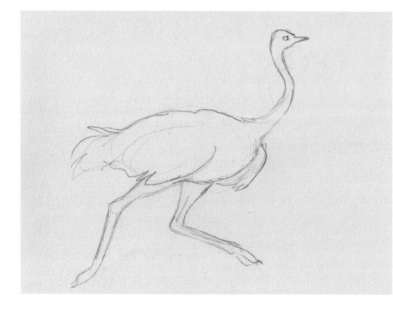

Step 1

The head to body ratio is extreme in these very large birds. Connect the tiny head and bulky body with a long, slim neck. The neck is held in a slight S curve and is about the same thickness along its length. To convey a sense of fast movement, the bird is somewhat unbalanced, its centre of gravity tipping forwards.

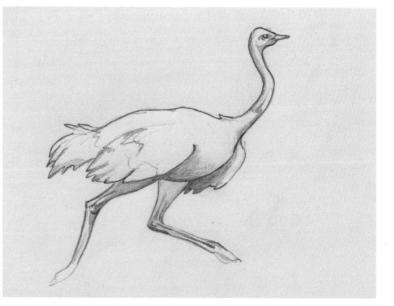

Step 2

Add shading to the shadowed areas of the bird. You can also add some feather detail, but this bird's size and the loose nature of its plumage mean that feather tracts are not clearly defined. Add detail to the muscular legs.

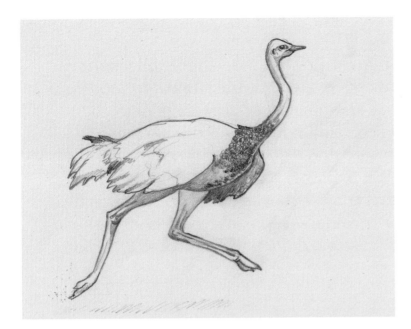

Step 3

Begin to add feather detail to the breast, making small, close-knit, curved marks with your pencil. The feathers are more like fur in their texture. Complete the detail of legs and feet.

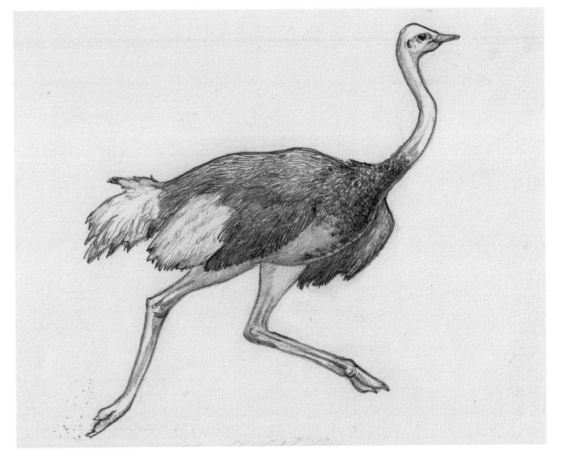

Step 4

Complete the drawing by filling in the rest of the body plumage using dense hatched lines, and increase the contrast between dark and light areas.

Gentoo penguin

Penguins are supreme underwater swimmers. On land, they waddle on short, stout legs set at the very rear of the body, but underwater they transform into superbly streamlined, flipper-propelled torpedoes. The gentoo penguin of the Antarctic region is extremely fast underwater and can also leap out of the water when necessary (perhaps to escape a marine predator). Its wings are modified into short, thick, powerful flippers, though they retain the same basic shape as any other bird wing, with a backwards bend at the wrist joint. The feet are used to paddle on the surface but they play relatively little part in underwater swimming and are held outstretched behind the body so as not to cause drag, in the same way that most birds hold their legs when they are flying.

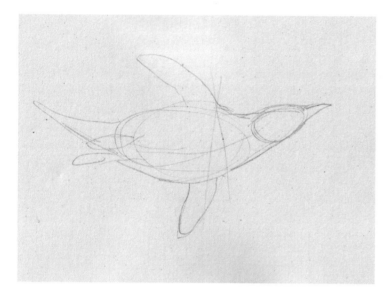

Step 1
Work out the initial outline. Drawing a bird swimming underwater is similar to drawing a bird in flight, but in flight the head, tail and body are usually held in a straight line, while swimming birds are more pliant (especially in the neck, as they are likely to be stretching out to grab prey with their bills).

Step 2
Consolidate the outline and add detail to the head. In the fast-swimming penguins, the facial feathers extend well down the length of the bill, smoothing out the shape and making the transition from head to bill exceptionally streamlined.

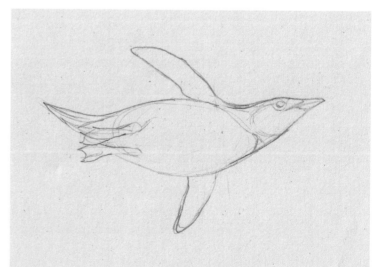

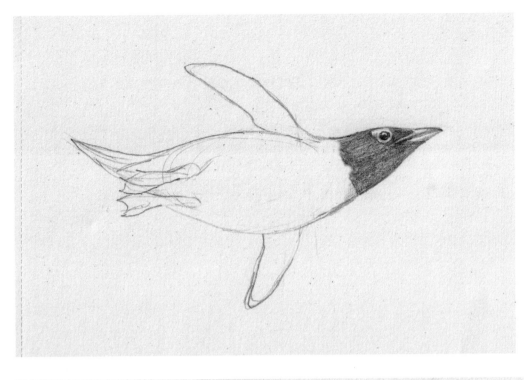

Step 3
Begin to add shading to the head, leaving a clear ring around the eye.

Step 4
Complete the shading, using a light touch for the shadowed areas of white underbelly. Use an eraser to correct any parts of the drawing you are unhappy with; here, the bird's left leg needed to be repositioned and redrawn. A few tiny bubbles are a simple way to indicate the underwater setting.

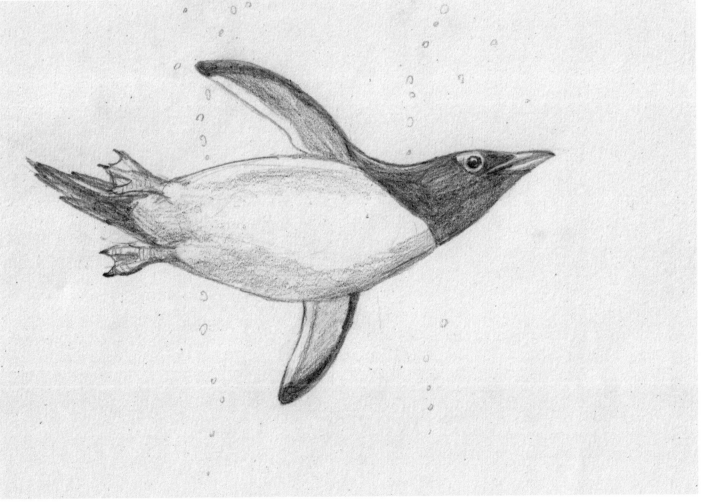

Shore larks

Many birds, including all passerines, are quite helpless when very young. They remain in their nests for some weeks and need to have food placed in their open mouths by their parents. Even when they are fully feathered and fledged, it takes some time for the begging habit to fade away, as they gradually learn to feed themselves. This drawing shows an adult European shore lark (known as a horned lark in North America – it enjoys a broader global distribution than almost any other passerine) approaching one of its fledged chicks with food. The fledgling, which was waiting patiently for this food delivery to arrive, begs with bill wide open. Drawing parent birds tending their chicks is challenging but can make for some charming images.

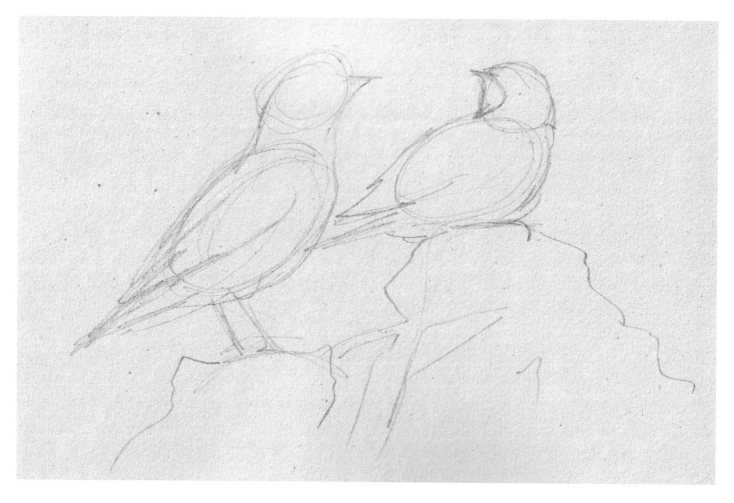

Step 1
Make your initial sketch. Whenever drawing two or more birds together, take the time to choose a pose where all of your subjects are in clear view and not overlapping each other in any problematic way.

Step 2

Firm up the outlines and add feather tracts. The fledgling is almost fully grown (which is the case for nearly all passerine birds once they leave the nest) but its wing feathers are not quite as long as the parent's.

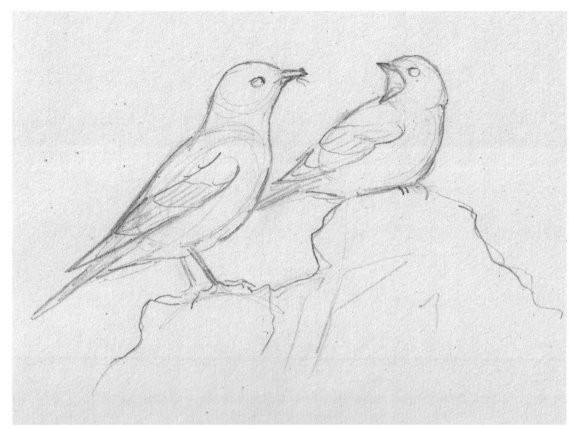

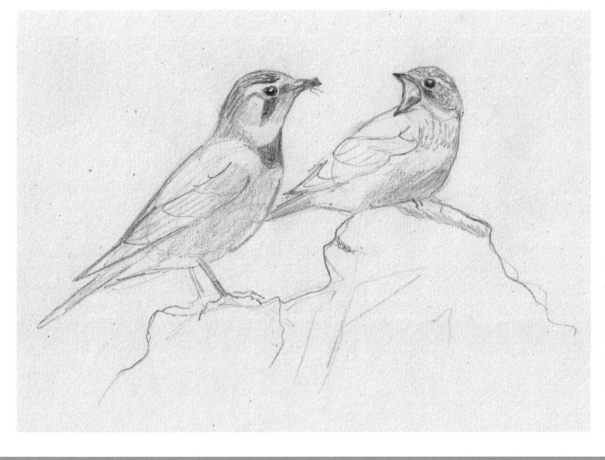

Step 3

Add some detail around the heads, including the dark, beady eyes with bright highlights. Note that the fledgling lacks the adult's bold face pattern.

Step 4

Add more feather detail and shading. The fledgling's wing feathers have a very crisply defined pattern, as the feathers are freshly grown (unlike the adult's, which are rather worn and will be replaced in the annual moult in a few weeks' time).

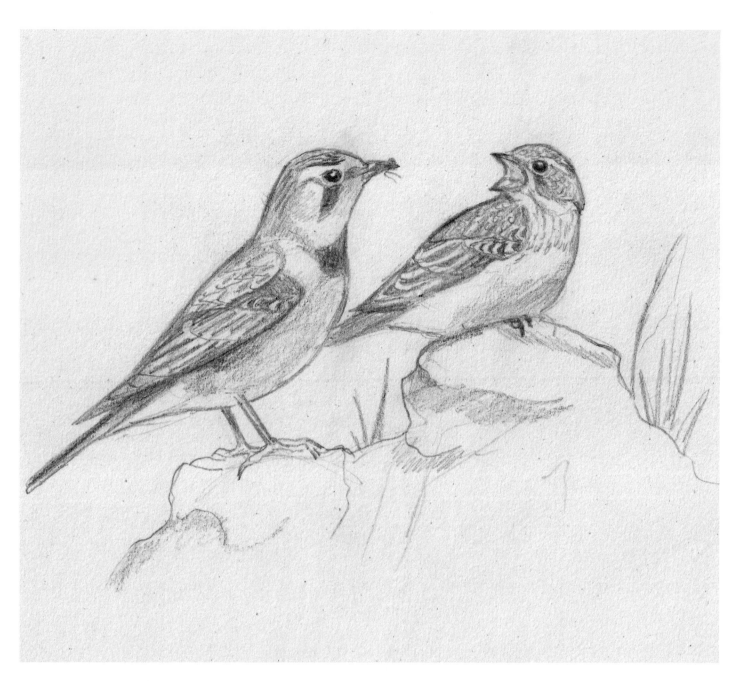

Step 5

Complete the picture by deepening the shading on the birds, and adding some detail and vegetation to the rocky environment.

Shorebirds

The most pertinent challenge of drawing a group of birds together is that some, inevitably, will turn out better than others. So take extra care with composition and the basic shapes of the birds, and be ready with an eraser to fix errors, improve poses or even remove entire birds if you realize that they do not work well as part of the composition.

Here a group of Eurasian shorebirds (pied avocets, dunlins and a black-tailed godwit) are shown in a shallow pool of water, each bird focused on its own activity – whether that be feeding, looking for food, resting or preening. Pay careful attention to relative size when drawing two or more species together, and make sure you place your subjects such that where their body parts overlap it will be clear which part belongs to which bird, and that all visible parts can be easily discerned. For example, it will be hard to see the dark-coloured bill of a bird in the foreground against the dark plumage of a bird standing right behind it.

Step 1
Make your initial sketch. The birds are arranged with the larger avocets behind the small dunlins, and the fairly large godwit standing slightly off to one side, but all of the five individuals have their heads and front parts of their bodies in full view.

Step 2
Firm up the outlines and add more detail, making corrections as needed. Here, the bill shapes of the pied avocets have been corrected – note that the bill is extremely slender and straight for most of its length, with just the last section upcurved. This shape allows the bird to dabble in the water, snapping up invertebrate prey, without having to immerse its head.

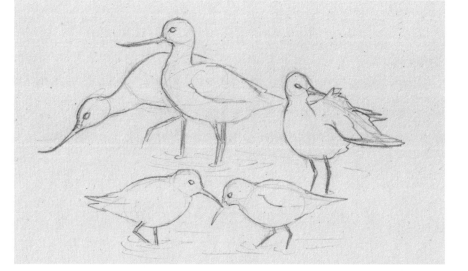

Step 3

Complete the black-tailed godwit first. It is especially useful to study a range of references when drawing a bird in an unconventional posture. Working on the right-hand dunlin, it quickly became apparent that this bird's pose was not ideal, and so it was changed to raise the head and give the bill some clearance over the head of the other dunlin.

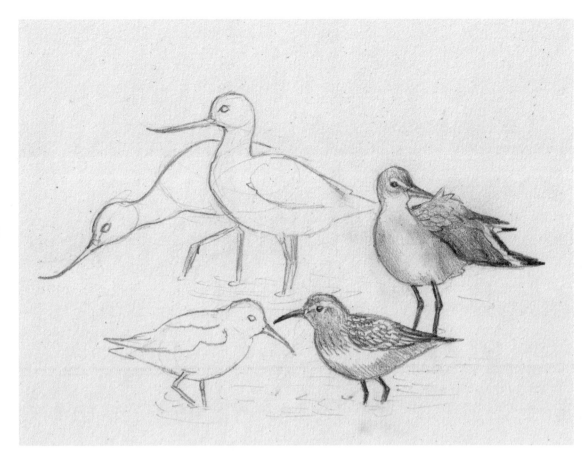

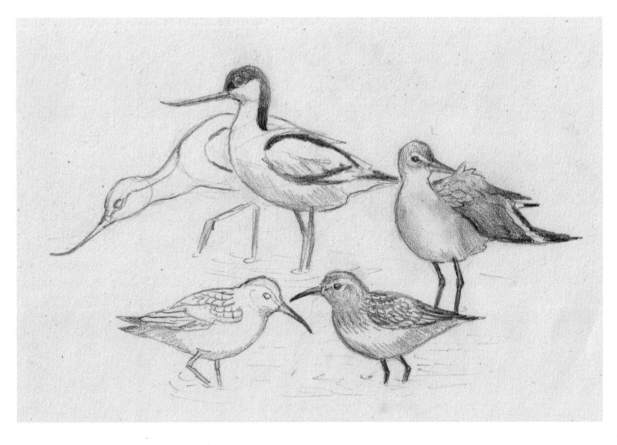

Step 4

Next, begin to add patterning to the central pied avocet. This species has an unusual wing pattern, so care is needed to get the black areas in the right places. Sketch out the patterning lines on the second avocet and second dunlin.

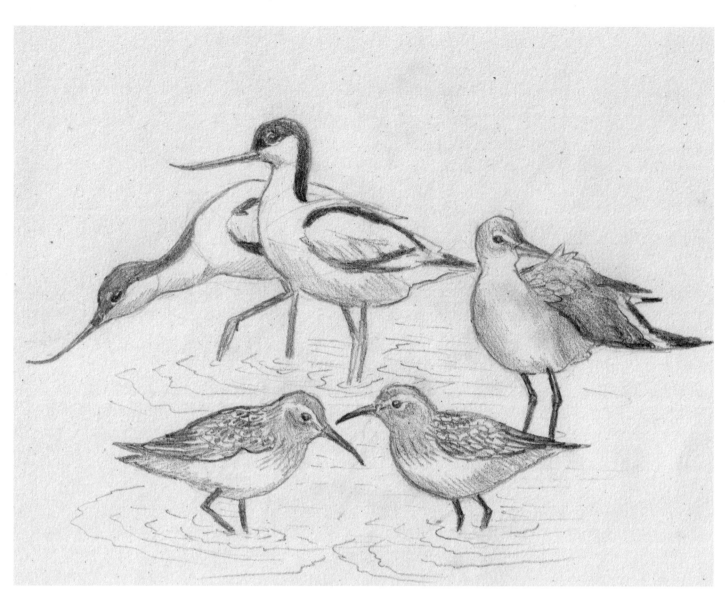

Step 5

Complete the last two birds in the group and add a little more detail to the water, which is drawn here in a very minimalist style with simple lines used to represent ripples in the surface.

Keel-billed toucan

Toucans are true oddities. Their grossly oversized bills are ideal for reaching and plucking fruits as the bird climbs in tree branches, and are extremely lightweight compared to other birds' bills, or the toucan would be absurdly top-heavy. The bill of the keel-billed toucan is especially colourful as well as very large. Swallowing a fruit picked with the bill tip is most easily accomplished by tossing it into the air and catching it further down in the bill or in the throat – a skill that toucans of all species have mastered to an admirable degree.

Step 1

The toucan's shape is quite extraordinary and even a very accurate sketch can look bizarre. The body is short and compact, with very short wings, and the length of the bill is about equal to that of the body.

Step 2

To complete your outline, make any corrections (here, the position of the eye has been corrected) and add some initial feather detail.

Step 3

Begin to add colour. The bill pattern and colours of the keel-billed toucan are unique and very striking, so pay careful attention to which colours appear where, and note that there is little blending of shades – each patch of colour is quite distinct.

Step 4

Colour the feet and perch and begin to add black areas of
plumage. The nape reflects a subtle violet iridescence, so
this is first shaded in with pure red-violet with a view to
overlaying some black at the next stage.

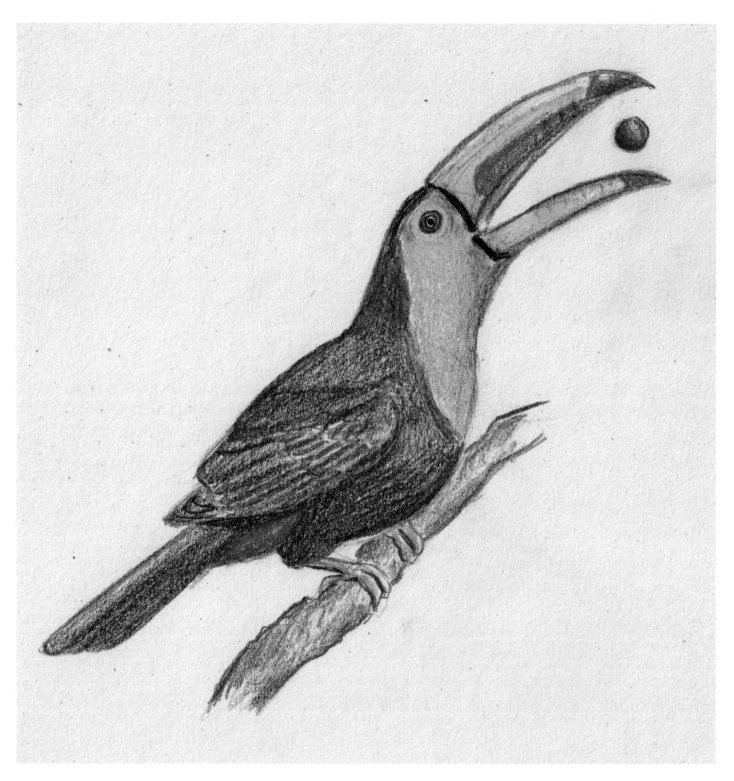

Step 5

Complete the shading, including on the branch perch and
berry, and add a stronger outline to the entire drawing to
give a crisper feel.

Rainbow lorikeets

A tender scene between a pair of birds makes a delightful subject for a drawing or painting. Here a loving couple of one of the world's most colourful parrot species, the rainbow lorikeet of Australia, is shown engaged in allopreening, whereby one bird preens the other's plumage. It is difficult for birds to preen their own heads and faces, so having a partner do it is a big help, and also very pleasurable going by the dreamy, eyes-closed look on the face of the recipient. Capturing the birds' intense colours in coloured pencil requires firm use of the pencils, and the use of a strong, dark outline helps retain clarity.

Step 1

Begin by sketching out the main shapes of the two lorikeets snuggled together, one bird partly turned to preen the head of the other. Note the peculiar shape of the bill when partly open – the lower mandible is rather blocky and does not come to a point.

Step 2

Note that, although they are angled differently to each other, each of the birds' bodies forms a straight line from head to tail. Also note the structure of the tail, with outer feathers shorter than inner ones. This graduated tail shape results in a pointed tail, even when the feathers are fanned out.

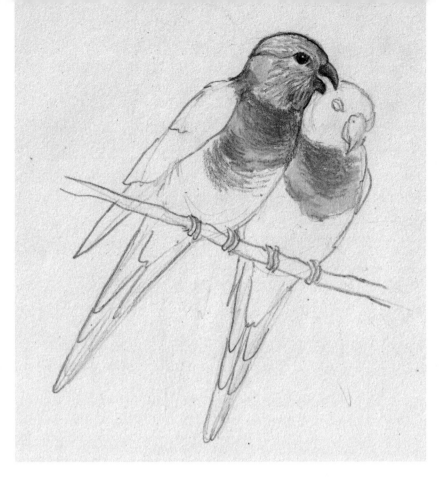

Step 3
Begin to add colour with coloured pencils.
These birds do indeed carry all the colours of
the rainbow in their vivid, variegated plumage,
so don't hold back on the intensity.

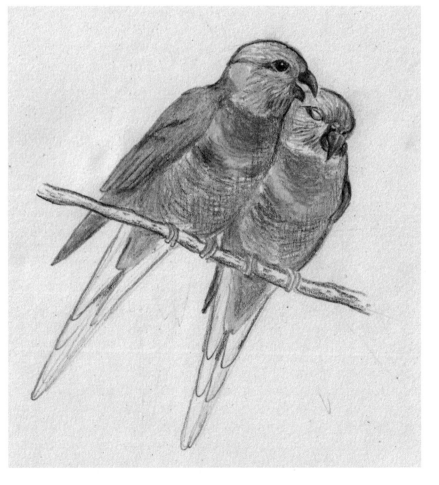

Step 4
Build up the colours and add more detail to the
faces. The recipient of the preening has its eyes
closed and is in a soft, fluffed-up and relaxed
posture, while the preener, actively engaged in
its task, looks sleeker.

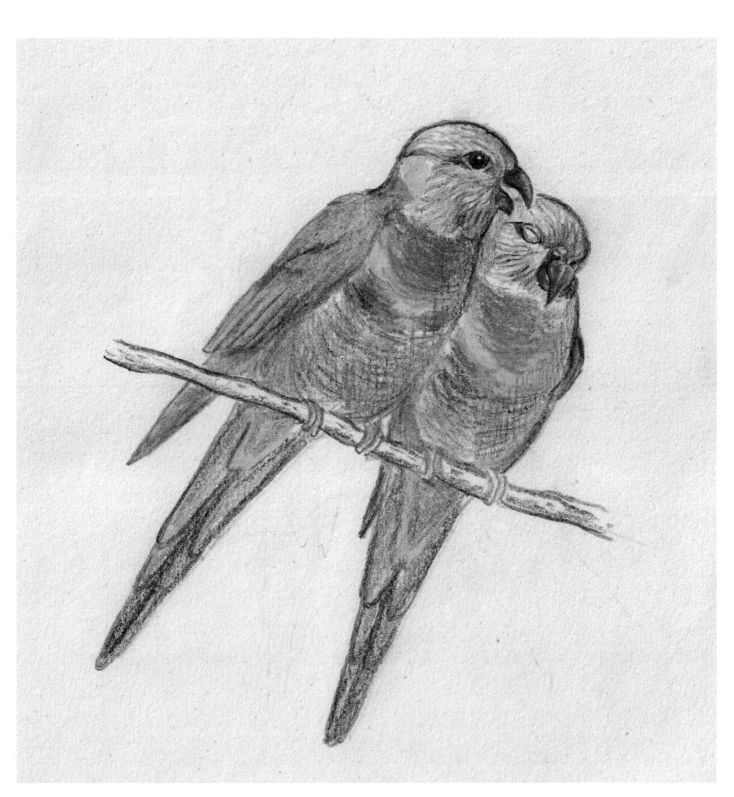

Step 5

In the final stage, colour the tail feathers and add more detail
to the twig perch.

Peacock

When we think of birds performing a courtship display, showing off their feathers to their best advantage, our thoughts naturally go to the Indian peacock with its astonishing fan of elongated tail coverts, marked with large and colourful eye-like patterns. Because these feathers are not, strictly speaking, the bird's tail (though they are much longer than the tail), they are often referred to as the 'train', as they resemble a bridal train when in their relaxed position. For this painting, the bird's beautifully marked face is shown against the backdrop of part of the fanned-out train of display feathers.

Step 1

In your initial sketch, focus on the head shape and face pattern. Mark the position of the fanned feathers and their spotted pattern behind the head.

Step 2

Work on your sketch, completing the detail of the feather positions and firming up the outlines on the head, ready to start painting..

Step 3

With your first washes in gouache add blue to the peacock's head and neck, with a little tonal contrast to show light and shade, and a green wash on the train.

Step 4

Using a very fine brush, paint in the bird's crest and refine the facial detail. Also begin work on the texture of the scale-like feathers on the crown.

Step 5

Wash in shield-like round feathers at the base of the train with a stronger golden green, and begin work on their detail. Continue work on the face and bill, and colour in the centres of the eyespots.

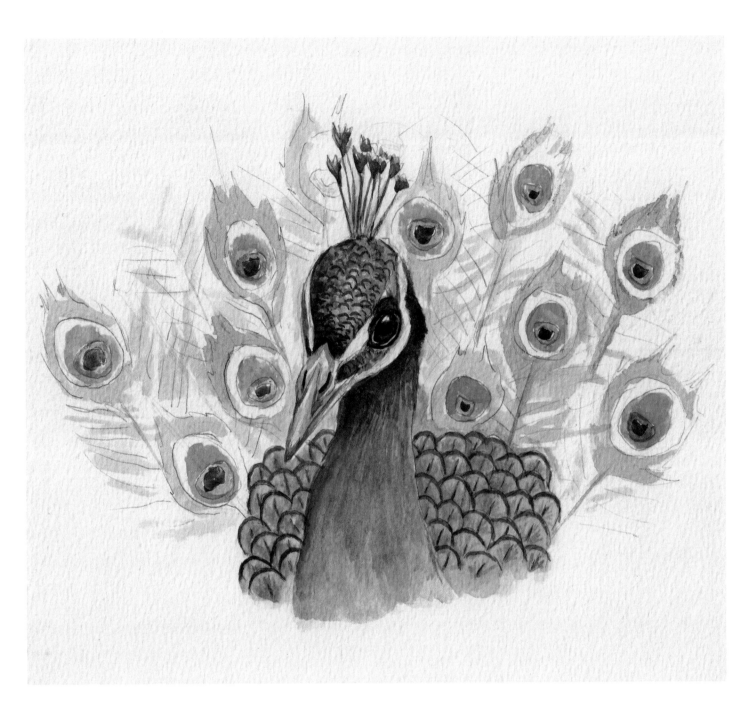

Step 6

Add a fine black ring to bring definition to the eye and complete the scale-like patterning on the crown. Add more colour to the eyespots on the train feathers and don't worry if your colouring isn't precise; the bird's head is in sharp focus but on the feathers behind, it is the overall patterned effect you are aiming to achieve.

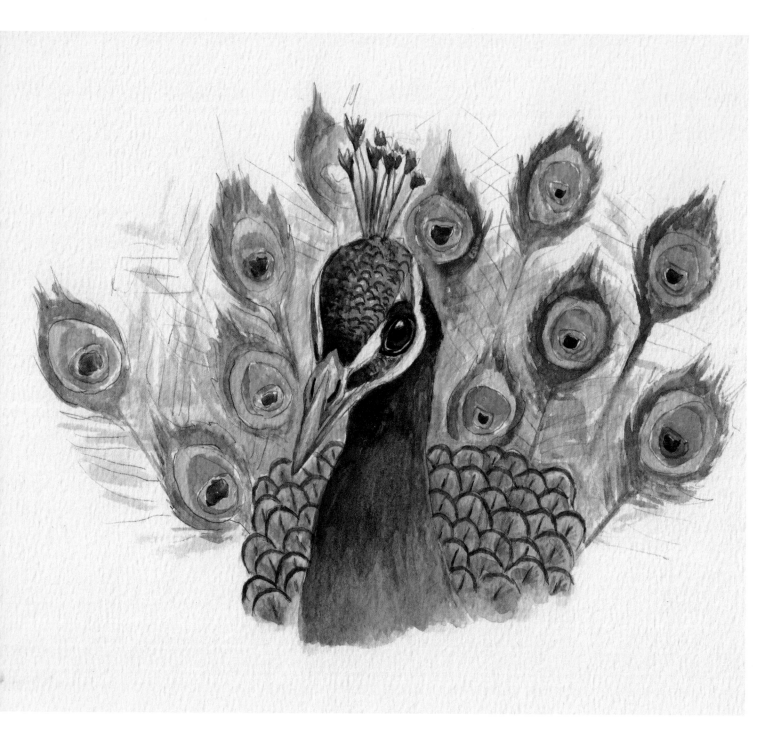

Step 7

Complete the concentric rings of the eyespots and add colour to the feathers around them, using different shades of green.

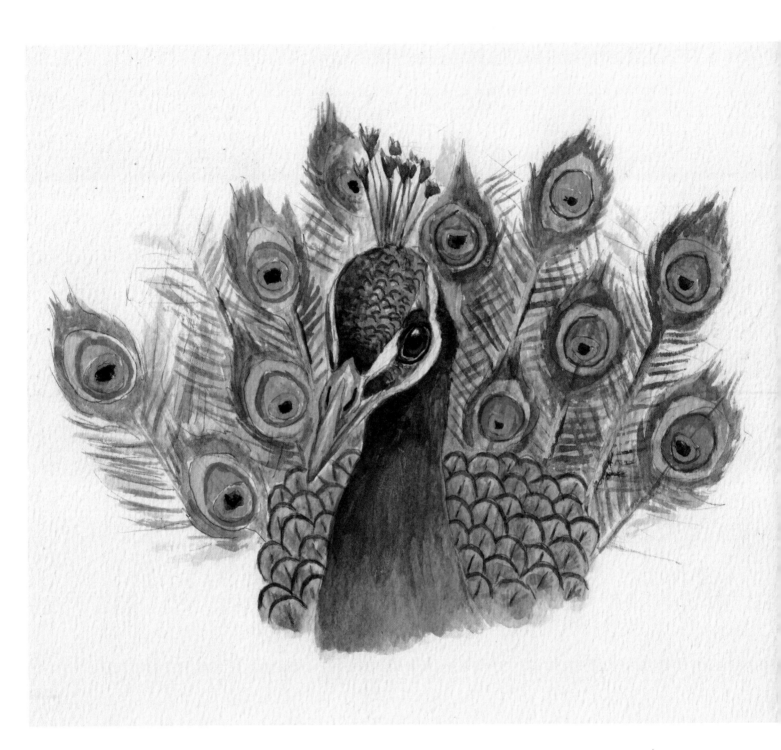

Step 8

It can be difficult to decide when a painting of this kind is actually finished, as it is tempting to keep adding more and more detail. The main addition at this stage is the side-branches to the feathers that bear the eyespots, which form a criss-crossing mesh pattern behind the bird's head, and the picture is complete (for now!).

Sketching from life

Drawing birds from photo references, or using guides like this one, is helpful for learning the basics of body proportions, the range of postures a bird can adopt, feather positions and textures, and other anatomical facts. However, it's also easy to forget that you are drawing a dynamic, restless, living animal rather than a posed specimen. The best way to inject extra life and vigour into your bird artworks is to spend time watching and sketching living birds. Active birds can go through a host of poses in the blink of an eye, so it's challenging to get any details down, but you will improve with practice. Here we will look at a few approaches that can make it easier. An alternative that you can try at home is to sketch moving birds from the TV or from online footage – this gives you the option of slowing down playback to give you a little extra time.

Capturing movement
Fast-moving birds, such as these European goldfinches, are frustrating subjects, but through observation and practice you will find you get better at capturing the essence of the bird in the bare minimum of pen-strokes.

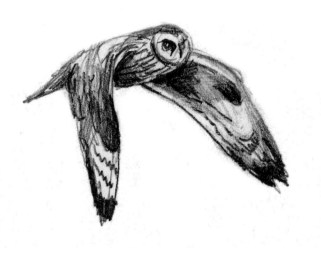

Late afternoon

Short-eared owls are often active well before dusk. They hunt on the wing and prefer open countryside, which makes them much easier to watch (and sketch) than most other owls. The light and shade is very strong in this rough-and-ready late-afternoon sketch.

Birds at sea

Watching the sea is a great way to see multiple birds of the same species in the same conditions. This juvenile black-legged kittiwake was one of many going by offshore, and in fact several different birds were used as subjects, with each passing individual providing another reference to add more detail to the drawing. Working in pastels on tinted paper is a technique suited to drawing light-coloured birds.

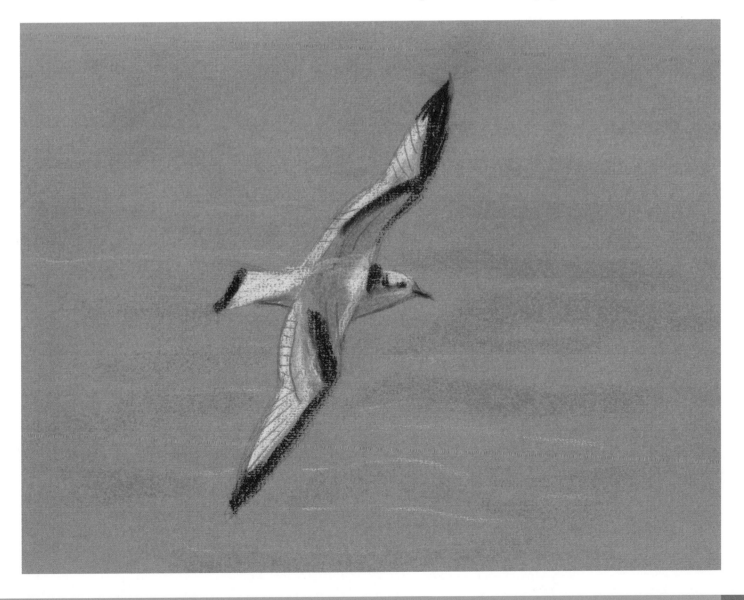

Fast sketches

Keep paper and pencils close at hand, especially near your windows, just in case you spot a bird outside that looks like a good subject, such as this preening European woodpigeon. These sketches are done very fast in a loose style, but working in this way helps you to see the moving bird as a whole entity, rather than a series of parts.

Birds in flight

When you want to hone your life-drawing skills on birds in flight, raptors such as this black-winged kite are a good choice as they often wheel around in the same area for a long period of time. The shadows that the wings throw across the body vary considerably as the bird moves through different positions relative to the light.

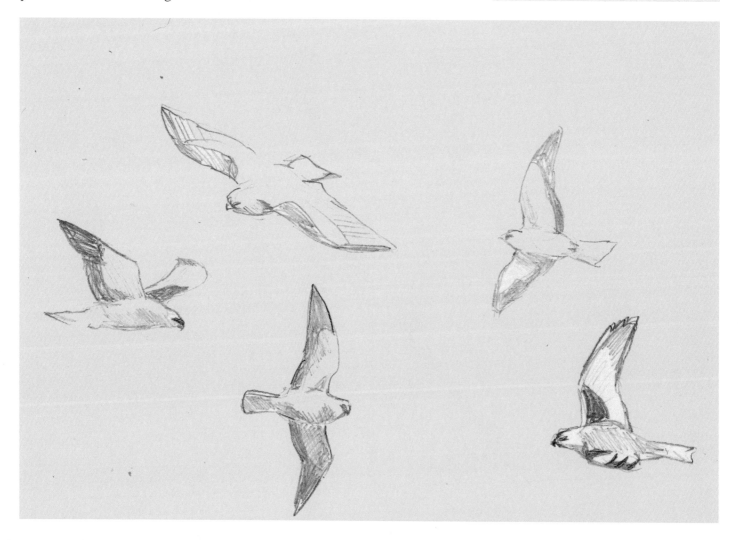

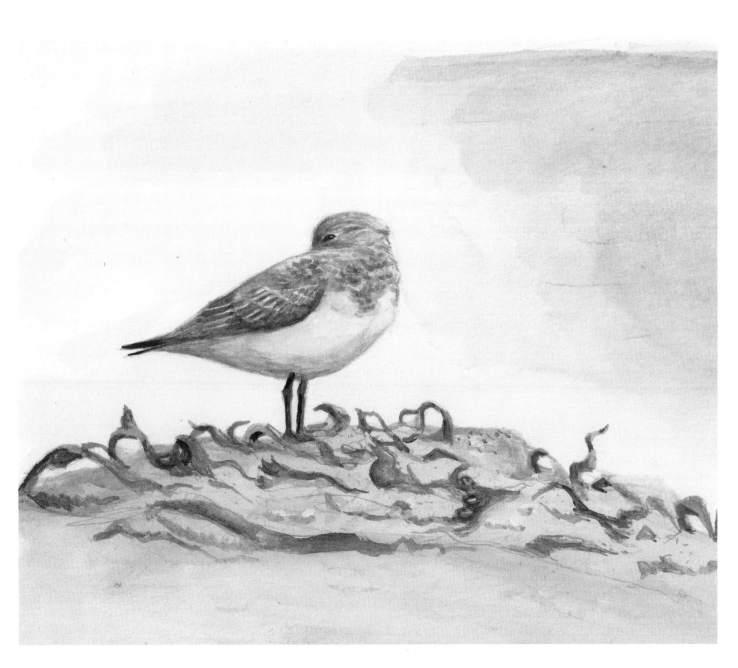

Painting from life

Sometimes birds are inactive for long enough that it's possible to complete a (quick) painting from life. Shorebirds like this sanderling often sleep in daylight, especially at high tide when the sea has covered up their preferred feeding places. Make sure that you don't disturb birds that are trying to rest – but if you sit quietly you may find that they come to you.

Index